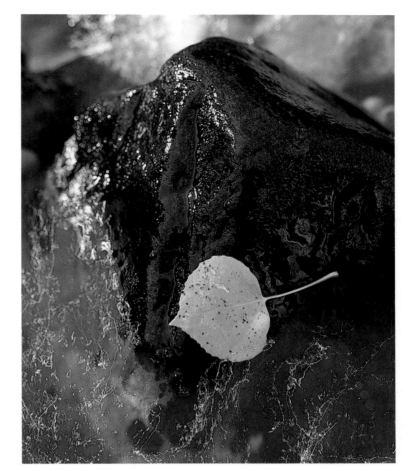

Earthtones

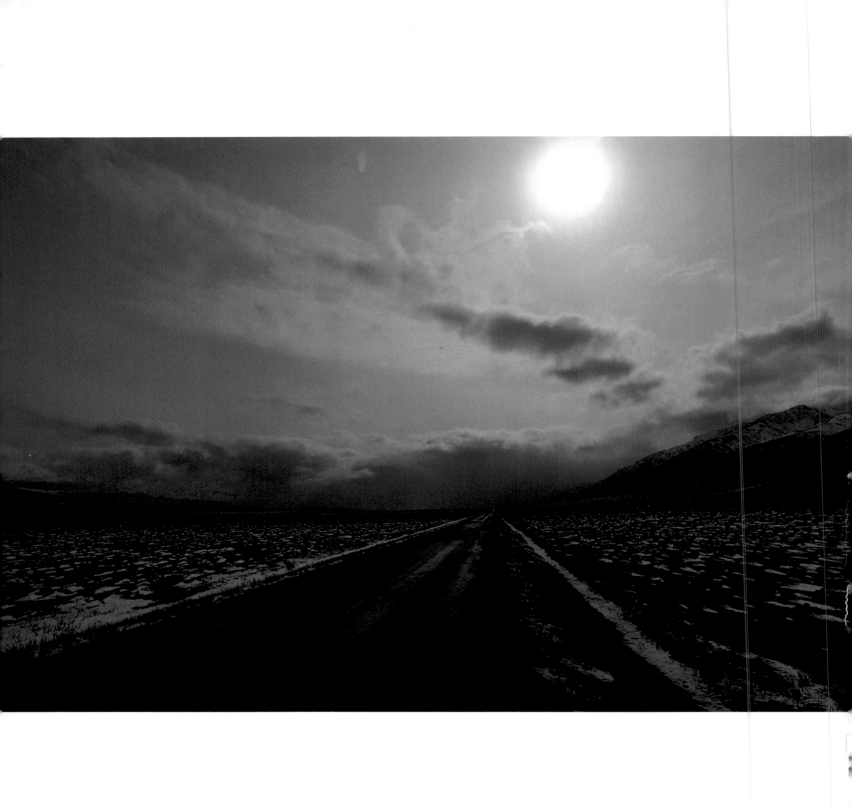

BOOKS BY ANN RONALD

Zane Grey
Functions of Setting in the Novel
The New West of Edward Abbey
Words for the Wild: The Sierra Club Trailside Reader, editor

BOOKS BY STEPHEN TRIMBLE

Blessed by Light: Visions of the Colorado Plateau, editor
Talking with the Clay: The Art of Pueblo Pottery
Words from the Land: Encounters with Natural History Writing, editor
The Sagebrush Ocean: A Natural History of the Great Basin
The People: Indians of the American Southwest
The Geography of Childhood: Why Children Need Wild Places, coauthor

Earth

tones

A Nevada Album

ESSAYS BY ANN RONALD

PHOTOGRAPHS BY STEPHEN TRIMBLE

University of Nevada Press ▲▲ Reno Las Vegas London

University of Nevada Press,
Reno, Nevada 89557 USA
Copyright © 1995 by the
University of Nevada Press
Photographs copyright © 1995
by Stephen Trimble
All rights reserved
Manufactured in China
9 8 7 6 5 4 3 2 1

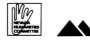

Winner of the Wilbur S. Shepperson
Humanities Book Award for 1995

This book is the recipient of the Wilbur S.
Shepperson Humanities Book Award, which
is given annually in his memory by the
Nevada Humanities Committee and the
University of Nevada Press. One of Nevada's
most distinguished historians, Wilbur S.
Shepperson was a founding board member
and long-time supporter of both organizations.

This book was funded in part by a
grant from the Nevada Humanities
Committee, an affiliate of the National
Endowment for the Humanities.

Captions for photos on front matter pages:
jacket: Bristlecone pines on The Table,
 Mount Moriah Wilderness, Snake Range.
half-title: Aspen leaf, Timber Creek,
 Schell Creek Range.
ii: Wet sage in winter, Big Smoky Valley, near
 Manhattan.
viii: Badlands slot, Cathedral Gorge State Park.
x: Pine Creek Trail, Red Rock Canyon
 National Conservation Area.
xii: Diana's Punch Bowl, Monitor Valley.
xiv: Jakes Valley, between the Egan and
 White Pine Ranges.
xvi: Sunset behind 13,145-foot Boundary
 Peak, the highest point in Nevada.

Library of Congress
Cataloging-in-Publication Data
Ronald, Ann, 1939–
Earthtones: a Nevada album / essays by Ann
Ronald ; photographs by Stephen Trimble.
p. cm.
Includes bibliographical references (p.).
ISBN 0–87417–270–5 (cloth ed. : alk. paper)
1. Nevada—Description and travel.
2. Landscape—Nevada. 3. Nevada—Pictorial
works. I. Trimble, Stephen, 1950–
II. Title.
F845.R66 1995 94–45450
917.93′02-DC20 CIP

For Marge Sill,
who taught us all to love Nevada
distances and dreams
A.R.

For Rick Stetter,
mentor and friend, who introduced
me to Nevada
S.T.

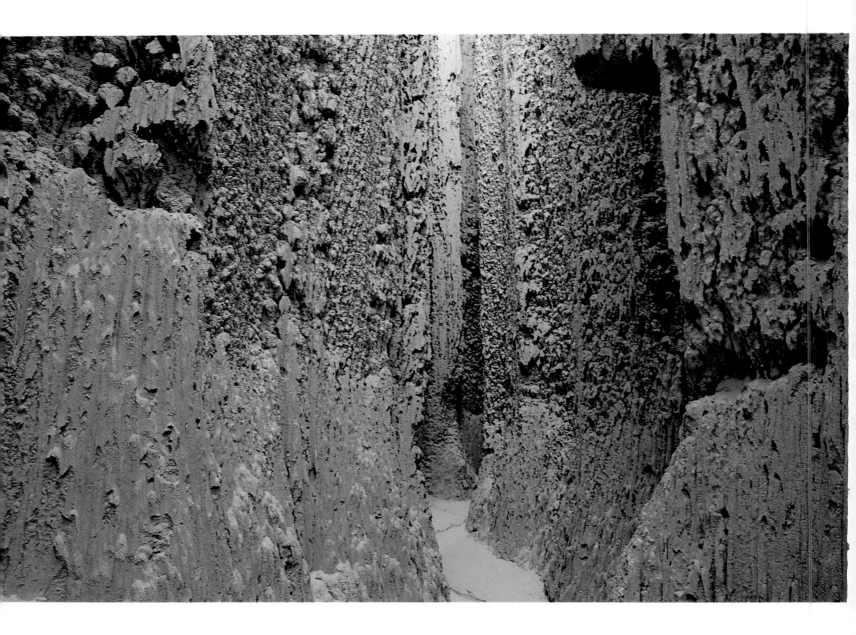

Contents

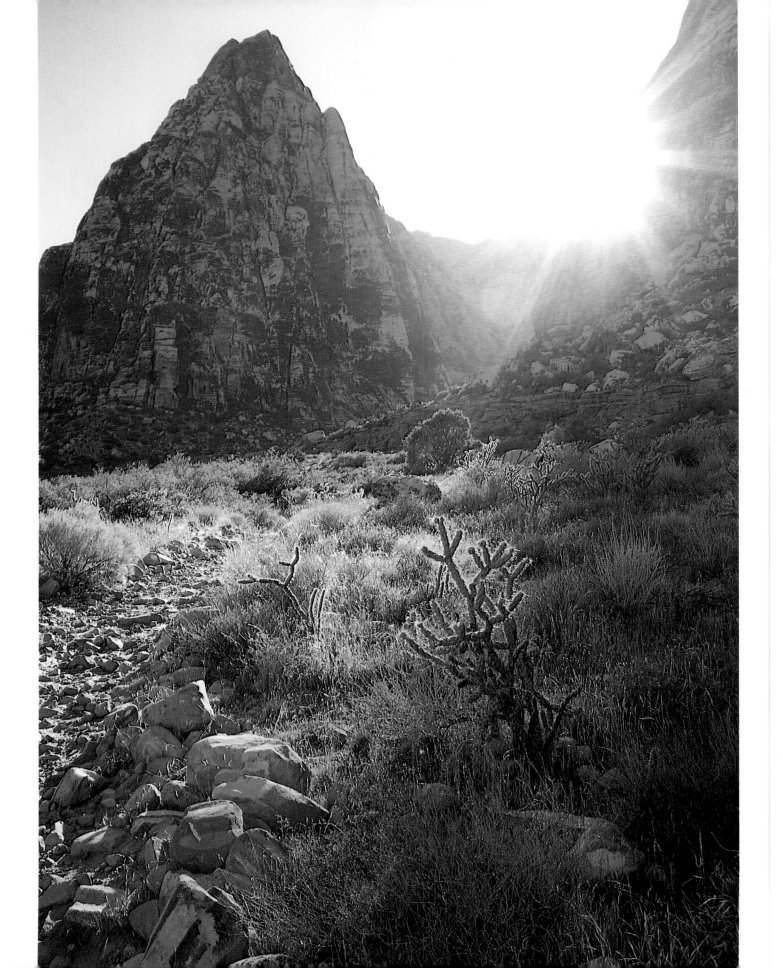

Collaboration

Rick Stetter, director of the University of Nevada Press from 1984 to 1988, first imagined this book and discussed it separately with each of us. Finally Ann and Steve met for the first time in 1989, at an Interdisciplinary Wilderness Conference held in Ogden, Utah. We talked, told stories, looked at maps, compared anecdotes, and decided how we might collaborate. Nearly five years passed before we found time to begin *Earthtones: A Nevada Album*, but as soon as we got started, we knew Rick was right. In prose and in pictures, we see the same Nevada.

The essays and photographs are complementary and equal, but our collaboration has never been lockstep. Steve made no effort to visit every place Ann writes about; Ann never viewed her prose as commentary on Steve's photos. Our visions are at once parallel and independent, interwoven and yet individual. While working on the book we stayed closely in touch, talking on the phone nearly every other week. But we have never hiked together, never camped together, never—other than one city-bound time in Reno—even been in Nevada together. We cherish a similar *Earthtones* landscape, however—the one we share with you in this book.

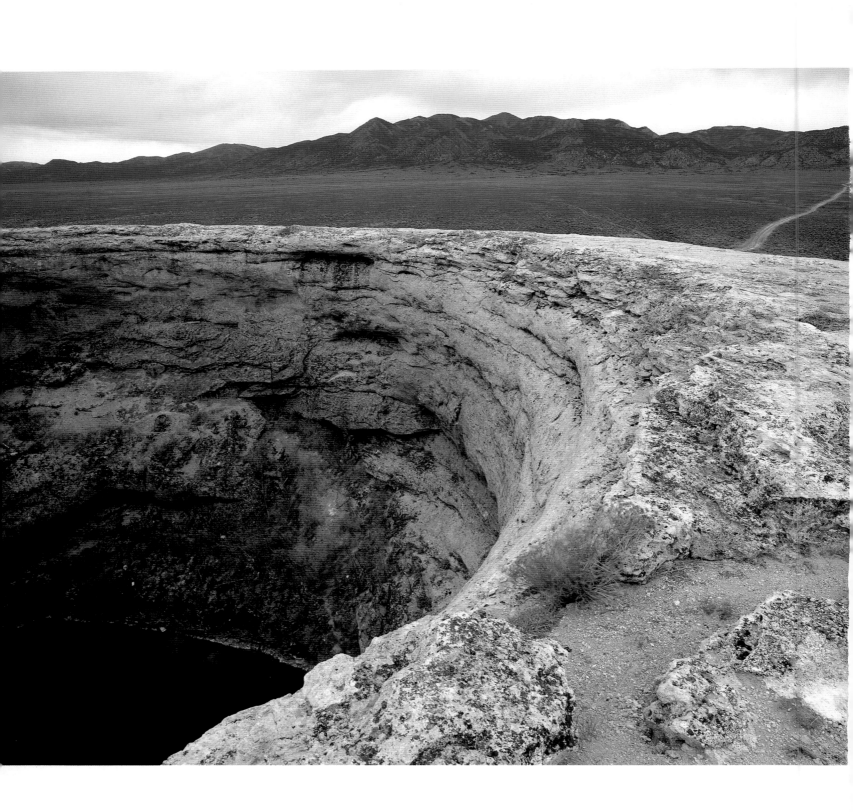

Notes on Photography

I photograph primarily with Nikon cameras—the F3 and the 8008S —using an array of Nikkor lenses from 20 mm to 300 mm. In addition, I am using a Pentax 6x7 system more and more. My film for years was Kodachrome 25, but now I shoot mostly Fujichrome Velvia, switching to Kodak Lumiere-X and Kodachrome 200 when I need extra speed. To obtain the sharpness critical for bookmaking, I am dedicated to a Gitzo tripod, cable release or self-timer, slow exposures, and small apertures.

I am not a technically oriented photographer. I make mistakes. I bracket exposures for every photo and edit my slides fiercely. I believe in a line that appeared years ago in an interview with Steve Crouch: asked what piece of equipment was most crucial to his work as a professional photographer, he replied, "My wastebasket."

S.T.

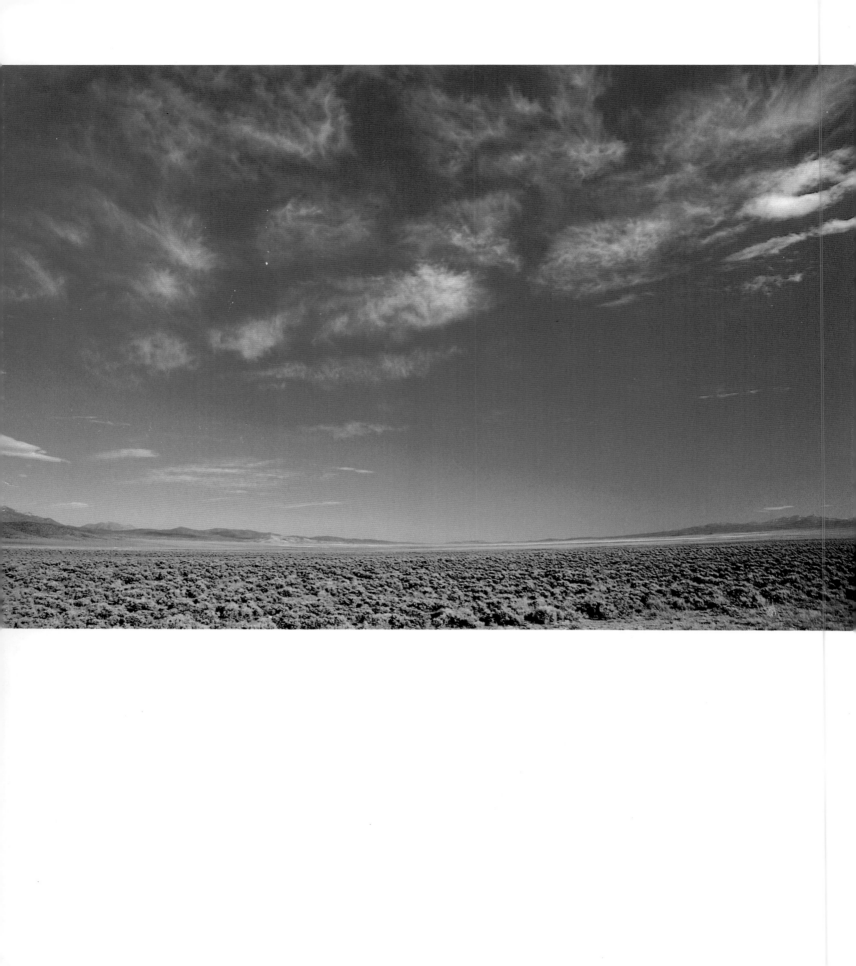

Acknowledgments

Many longtime friends have crisscrossed Nevada with me, on foot and by four-wheel drive. Without Ellen Pillard, Marge Sill, Dennis Ghigliari, and Rose Strickland, I might still be lost in the Silver State's open spaces. Others helped guide my travels, too. Howard Booth, Pat Cashman, Lynn and Dave Herman, Pat Hicks, John Jencks, Ann and Greg Kersten, Bob McGinty, Tina Nappe, Tracey Pharo, Lee Schultz, Dick Sill, Theron Turley, and John Van Houten led me to secret places. Grace Bukowski, Jim Carr, Nevada Coates, Kay and Don Fowler, Cheryll Glotfelty, Shawn Hall, Mike Hess, John James, Stephanie Livingston, Alvin McLane, Jim Nichols, and Elizabeth Raymond helped me find the right words to describe what I saw.

Without Steve Trimble, those words might languish on these pages. I owe him enormous thanks for joining his photos with my prose, and for making this project so much fun. I am grateful to the University of Nevada, Reno Library Special Collections staff, too. Bob Blesse, Linda Perry, Susan Searcy, and Kathryn Totton not only gave me shelter but pointed me toward the resource materials I needed. Lois Snedden gets the most credit for *Earthtones* navigation, though, as captain and compass and crew.

A.R.

First thanks go to Robert Laxalt and Rick Stetter, who brought me to Nevada fifteen years ago to photograph for the University of Nevada Press Great Basin Natural History Series. Second thanks—of course—go to Ann Ronald, who pursued the idea of our collaboration with cheerful persistence and completed it with efficient professionalism. Working with her on this project has been a treat.

My family deserves the rest of my thanks. On our journeys into Nevada, my wife, Joanne Slotnik, has come to share my love for the Great Basin. Her enthusiasm is inspirational, and her patience with my time away for fieldwork is appreciated. In the summer of 1994, I began to take my six-year-old daughter on field trips—just the two of

us. I love the fact that these experiences may be among the stories Dory someday tells of her childhood. I am looking forward to the time when her brother, Jacob, is old enough to go with me as well.

S.T.

Both of us appreciate the care and efforts of the staff of the University of Nevada Press in seeing this book through production. Thomas R. Radko, Cameron Sutherland, Sara Vélez Mallea, and Sandy Crooms deserve special thanks.

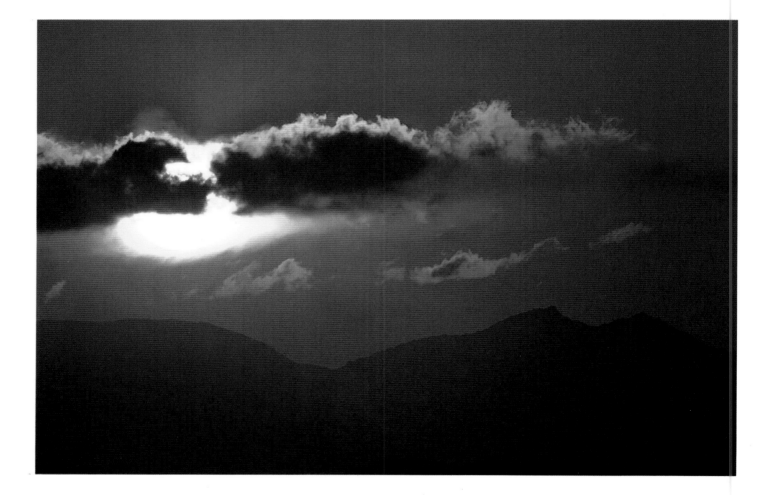

Earthtones *An Introduction*

Too many people picture Nevada landscape the way eastern newspaper reporters and urban advertising agencies imagine it. High-Rise Casinos and High-Tech Theme Parks. Frank Sinatra and Barbra Streisand. Liberal Slots, Computerized Poker, Craps. A Get-Rich-Quick Mentality. Glamour, High Rollers, Spectacle. Holiday neon punctuating empty terrain. The previous generation's Nuclear Test Site. The next century's Hazardous Waste Dump. Mile after mile after mile of America's Loneliest Roads.

Few tourists, few essayists, few photographers bother with the sparse horizons beyond the neon, the lonely wilderness spaces of California's less comely neighbor to the east. Writing five short essays now collected in *Steep Trails*, John Muir set what I consider an unfortunate aesthetic tone. He described Nevada scenery as "a singularly barren

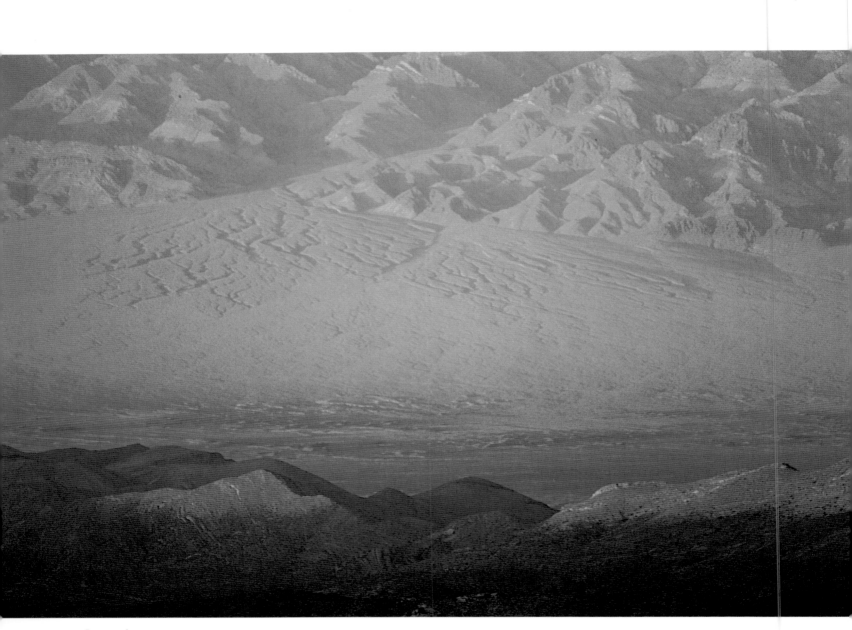

*Sunset colors an
alluvial fan in the
Desert National
Wildlife Range.*

aspect, appearing gray and forbidding and shadeless." Even though Muir admired some isolated peaks and valleys, he generally treated the Nevada landscape harshly. Calling the Silver State "this thirsty land," he imagined it "like heaps of ashes dumped from the blazing sky" and summarized his feelings by envisioning "one vast desert, all sage and sand, hopelessly irredeemable now and forever."

Someone blankly staring through a car window might well agree with Muir's dry assessment. Rivers are few and far between. Interstate 80 stretches across a lot of sand and sage, with only an occasional glimpse of the evaporating Humboldt that weary pioneers trailed 150 years ago. Highways 50 and 93 and 95 alternate sinewy mountain passes with flats of alkali and dust, relieved only by winter snow or summer cloudbursts. None of these major routes is scenic in any conventional way.

Nor are the views from an airplane window any more obviously picturesque. While a casual traveler might glance once or twice at the striations of brown, chocolate, and beige, might briefly puzzle over the shadowed ridgelines, might even shake his or her head at the vacant horizons below, most find more pleasure in the refreshments being served. My seatmate last October, making idle conversation, echoed the Illinois couple I overheard at an interstate rest stop two months before: "What is there to see out there?" "It's so empty." "It's so drab." "It's so depressing."

One of Wallace Stegner's essays, "Thoughts in a Dry Land," touches briefly on why we are unable to change our aesthetic minds about what is scenic and what is not. He insists that we have to get over the color green. Stegner is right, of course. Almost all of us have been taught a worldview that prefers green and blue to ocher and beige, that values redwoods and oceans more than rabbitbrush and sinks. Stegner concludes by saying that we inherently lack appreciation for such things as sagebrush and raw earth and alkali flats. These, he suggests, are acquired tastes, ones not easily adopted by conventional sensibilities.

Empty space, and the concomitant exposure of geologic time, are acquired tastes too. As someone who grew up in the forested Pacific Northwest, I not only was indoctrinated by the beauty of green but I also was comforted by vine maple, maidenhair ferns, and shin tangle. The near view—perhaps a high meadow filled with purple gentian, perhaps the riffle of a stream—was pleasingly, narrowly defined. Any long view was supposed to be grandiose in a European kind of way, punctuated by two-hundred-foot Douglas fir and glaciated peaks with romantic-sounding names. I possessed no imaginative comprehension for the shapes and shades of basin and rockbound range in a "land of little rain."

Now that I've spent nearly twenty-five years tracking such desert distances, however, I've developed a very different aesthetic eye. From the air, I ignore my seatmate's imprecations and look down on a Jackson Pollock oil. Framed by the plane's window, the colors stipple from black-topped ridges to creamy basins with pale cuts muted red, like dried blood. Curved washes narrow, then widen, then narrow again. The trace of a river twists into tight coils, a series of oxbows unwilling to dry themselves out. The shadows that follow the oxbows are metallic tints from a desiccated palette. Sere green—not emerald hues, but tones befitting the jaded contours of the land below.

Closer to the ground, heading east to west across a lonely highway, I picture not a gallery hung with postmodern paintings but a film unrolling before my eyes. Rounded hills fold into wrinkled cavities, amber curves sharpen against a darker sky. An evening raincloud spills from its top a Niagara that will never reach the earth. Three mustangs browse silently through the yellowed grasses. At the sound of my truck approaching, two golden eagles erupt from the pavement. One, clutching a roadkill rabbit, flies off; the other, settling on a nearby fencepost, glares at the highway. I stop the truck, grab my binoculars, and stare back at the huge bird.

That's what the man and woman from Illinois might have seen, had they known that scenery need not be green, that shapes and shadows may segue into figures and forms, and that seductive details can be spotted when one goes slow. If they had strolled out into the sage, they might have discovered how much a single lens can reveal. In springtime the brown hills turn lime velvet for a week or maybe a month. Even after a dry winter, showy phlox the size of my little fingernail cluster underfoot and alongside abandoned dirt roads, while a wet winter brings forth a patchwork of purple lupine. Blizzard white transforms lumpish limestone blocks into peaks reminiscent of the Alps, while cloud shadows in any season writhe the distance into a close-up kaleidoscope of colored motion.

Too many visitors to the Silver State never see my Great Basin. Or, if they do see it, they don't know how to describe it. Their Nevada is a preconceived one, a product of instinct, intuition, and intellects unwilling to look favorably at dry desert scenery. Their Nevada, I'm afraid, is an unfortunate cliché. *Earthtones: A Nevada Album* presumes to refute this point of view. Neither "a singularly barren aspect" nor a landscape "hopelessly irredeemable, now and forever," our Nevada is one seen through sympathetic eyes.

Teal sky and a sea of purple sage. Mountain mahogany, white fir, a crimson mass of claret cup cactus. Rawhide Springs and Green Monster Canyon. A bobcat tiptoeing along Corn Creek. Desert tortoise, a marmot whistling for his mate, a nesting long-eared

owl. The Black Rock playa, Lake Lahontan. Currant Mountain and Duckwater Peak, Rainbow Canyon and Calico Hills. Limestone, sandstone, and tuff. One stone wall, a few broken bricks; dry alfalfa, an empty irrigation ditch. A dust-blown sunset, vermilion and orange and gold. "One vast desert?" Not exactly. One vast deserted landscape of color and shadow and aesthetic dimension.

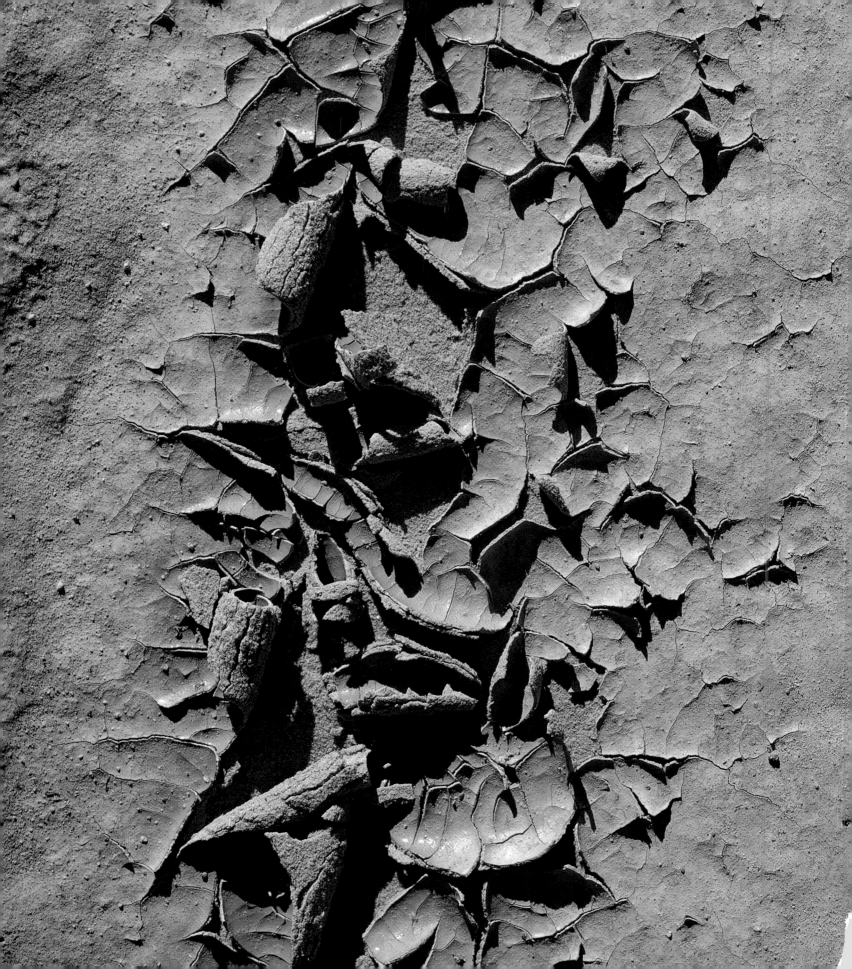

Colors

If Las Vegas isn't exactly a pot of gold at the end of the rainbow, its natural surroundings in fact resemble the rainbow itself. While the rest of Nevada takes pride in an occasional cliff or wash that looks like Neapolitan ice cream, the southern tip of the state boasts whole preserves of vibrant colors. There you can explore Red Rock Canyon and Valley of Fire and Calico Hills and countless smaller lifts and cuts, sculptured and varnished, sandstone and tuff.

Seekers of colorful scenery don't have to go far. A sign outside the Red Rock Canyon Visitor Center reads: LAS VEGAS, 17 MILES. It must be an old sign, for just seven miles away the first subdivision appears. That's how close the city edges toward a Bureau of Land Management National Conservation Area that attracts local residents and tourists who venture out of doors. Of those who do follow Charleston Boulevard out be-

Mud drying along a wash forms a badlands in miniature, Cathedral Gorge State Park.

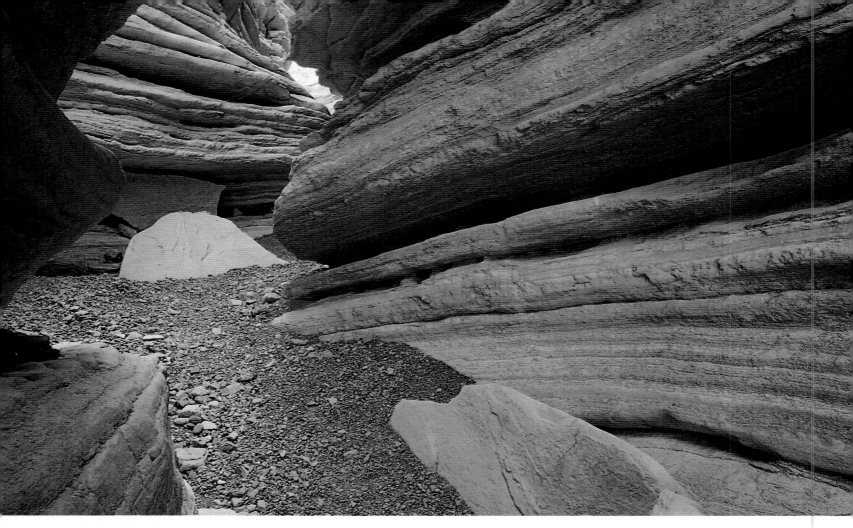

Southern Nevada's Lovell Wash carves a narrows of sudden intimacy.

yond the last of the newly built houses, most visitors choose one of two activities. The more sedentary continue driving along a thirteen-mile one-way road that leads past numerous photo opportunities. The more adventuresome test their skills on well-used climbing routes that dot the sandstone formations. Viewers can enjoy either the scenic drive or the hundreds of bedecked climbers who accent it.

What seems like a Disneyland for cars and climbers, however, is something quite different for the hiker who leaves the first tier of sandstone behind. Beyond that photogenic face, the red rocks blend with the Calico Hills in twists and swirls of layered color. Those cross-bedded sandstone hills, with their reds and beiges and reds and whites and reds and blacks and chocolates and reds give true meaning to the word "calico." At any given moment and with every change of season, the colors brighten or blend together, fuse, separate, or blur. What might be golden-pink at dawn, deep magenta just before nightfall, and a washed-out khaki at noon may bleach almost white in August or darkly disappear under streaks of black during a January rain. Because the

Within Lovell Narrows, full desert sunlight gives way to walls glowing with color.

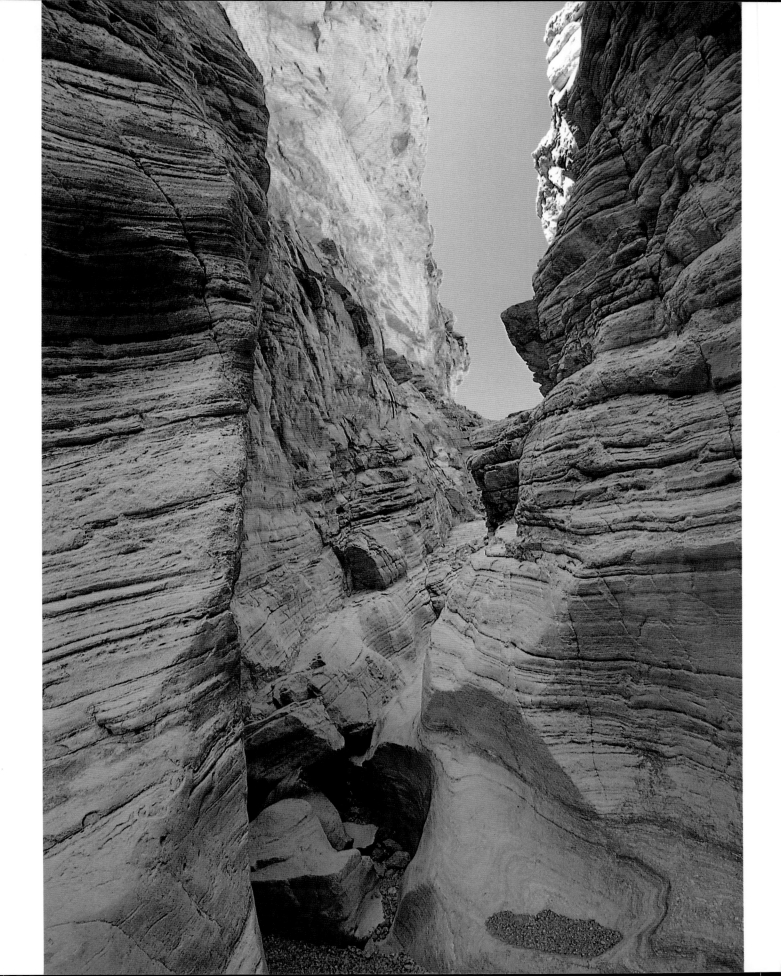

sun's position and the now-and-again cloud cover dictate every hue, none of the shades remains constant for long.

Less ephemeral than the colors are the rocks themselves. Slabs can fall on the unwary, but since I personally have never seen one of these multi-ton giants tumble into a new position, I prefer to think about such possibilities only in terms of epochal chronology. The massive scenery does make me feel fragile, though. When I last hiked up to the Calico Tanks, just after the 1994 Southern California earthquake, I noticed how precariously the chunks of red and layered tons of honey were poised. Then I sat and watched for a while and saw sandstone shapes change, but only in my zoological imagination. Lines and folds and blocks and pieces and angles and corners and pockets helped me conjure a set of companions. That angular chunk, a lizard poised to jump; this rounded one, a horned toad. Over there, a thirty-foot Irish setter, his red tongue a swirl of overlaid gypsum. Tucked in a side canyon, a giant Buddha with his arms crossed. And to the south, where red gives way to cream, I'm sure a fat hippopotamus squats next to a scaly rhinoceros while an aging wrinkled elephant watches them both.

Geological events both dramatic and quiescent account for the formation of Red Rock Canyon and the mountains to the west. Once covered by an ancient shallow sea, then drying in a Mesozoic sun, trapped sediments from evaporating mud slowly rusted into the shades of red we see today. The Jurassic phase brought blowing sands into the picture, creating dunes that long since have fossilized into humps and shapes fantastic. Even volcanoes took part in the action, spewing ash into the area, mixing up a chromatic panoply of iron oxide, calcium carbonate, pink rhyolite tuffs, and sand. Many more millions of years passed, during which the earth continued to move, until the ongoing action burst into great dramatic heaves.

I hiked back to the Red Spring thrust fault to see one of the biggest fractures. The canyon itself looked like most such red-walled watercourses, with colorful slabs and layers, a trickle of water and a few leftover pools. Settling on a chunk of black limestone hung out over space, I studied the pink and red sandstone below. That's backward, I thought. The sandstone came after the limestone, so it ought to be on top. Geologic forces more powerful than I can imagine uplifted, dramatically tilted, and turned the landscape upside down. I climbed a nearby hill, where the dark black rock resembled solidified crumpled newspaper full of stiff crinkles and pockets, and looked down again. When I tried to lean against the bare limestone, jagged old rocks dug uncomfortably into my legs and hands. The younger sandstone below me looked so much smoother that I almost regretted—for one of the few times in my life—picking a high lookout for a lunch spot. While I ate, I thought about this hillside on its cataclysmic journey. Scientists agree

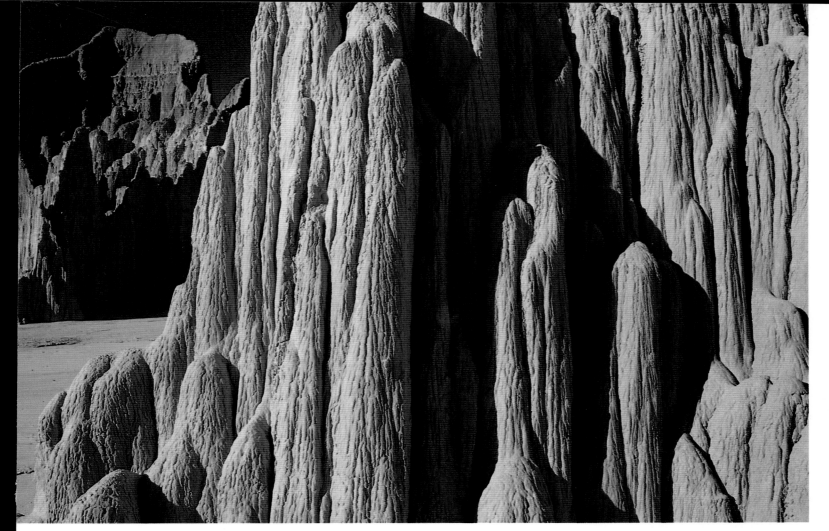

the earth slid nearly sixty miles, so my perch could have started from Pahrump to the west and ended up here with an east-facing view of Las Vegas.

Scale isn't necessary for artistry, however. Near Reno, for example, I often hike in a place called Incandescent Rocks. It's an insignificant little canyon perhaps two miles long, maybe ten feet deep, sometimes only three or four feet wide. Its mouth is guarded by bittersweet chunks of chocolate limestone that look like they were eaten by giant prehistoric earthworms. Crawling over and through the paths and caves and hollows, I imagine myself disgorged. Beyond the limestone, a waterless waterfall blocks the way. A March thaw or an August downpour might send runoff down its cracks, but most of the time the sleek black wall hangs dryly in the desert. Above the rockbound slide, licorice and chocolate give way to cherry and strawberry tones more often associated with landscape five hundred miles to the south. The colors intensify as the canyon narrows. Through its midsection, I can reach out and touch both orange-pink walls at once, or I can just step out of the narrow parts, into sage and rabbitbrush and brown dirt. Another

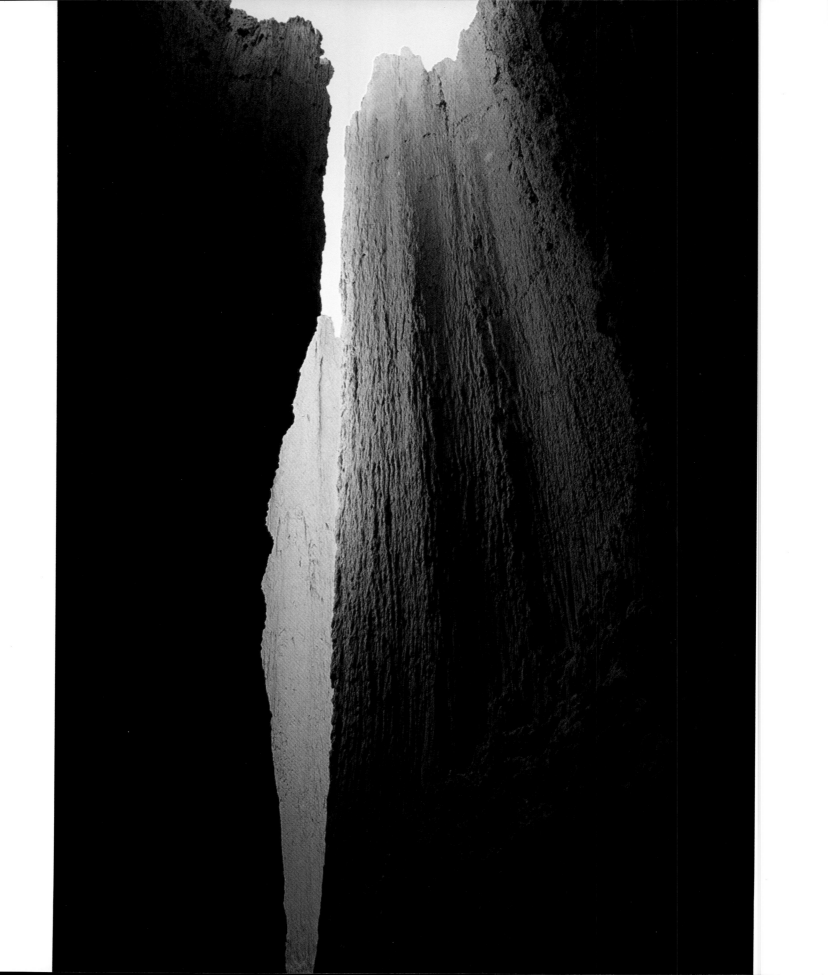

step, and I'm back in an iridescent canyon that fits the hiker like a glove. Once I followed bobcat tracks that tiptoed in and out too.

If the bottom is chocolate and the middle strawberry, the disintegrating top is pure vanilla. A scramble up the layered colors—it's easier to climb on the pink and avoid the white—brings me out on top. From there I see the turquoise of Pyramid Lake immediately to the east and the coral of Incandescent Rocks below, a Navajo bracelet of water and stone. Just as so many Las Vegas flights descend across the Red Rock National Conservation Area, most planes into Reno swing over this colorful little canyon. But unless you were specifically looking for it, you would hardly notice the colors buried against the barren hilltops. When I first moved to Nevada, I didn't understand why anyone thought Incandescent Rocks so special. Now I realize this minor canyon typifies all the little rainbow cuts that mark up northern Nevada browns. Not very big, not very spectacular—not like Red Rock Canyon, not like Luxor or the Mirage.

Southern Nevada has its own special places tourists won't find, secret niches uniquely shaped and colored. One of them, appropriately called Rainbow Canyon, sits just off the Lake Mead Highway. Though the canyon is considerably longer, I can walk the most colorful part of it in just a few minutes. Perpendicular striations slide from its mouth in shades of golden amber and apricot magenta. Unlike the iron-tinted rocks a wash away, this canyon's slanted walls are fall-toned and fruit-stained, new-mown hay and red delicious and pumpkin. Then the walls turn white. "One of those minerals that all look alike," a geologist friend laughs.

A tracer tunnel, dug half a century ago by prospectors seeking productive ore, dead-ends into the cliff. Just half a mile distant, owners of a mine abandoned in 1928 were more successful. Unearthing 200,000 tons of colemanite ore, an important source of boron, they earned a million dollars. Pink dumps and miles of the Anniversary Mine tunnels still exist. So do broken bricks, concrete slabs, stone walls, steel rods, and rusty rails barnacle-encrusted with rocks. A weathered old sign nearby, posted by the Las Vegas Gem Club, invites amateur collectors to look for lilac agate, Christmas agate, petrified algae, bacon agate, travertine. No power tools allowed.

What must once have been an area alive with miners and machinery now sits silent and forgotten. So, too, the colors around the mine site seem subdued and pale. Now and then I catch sight of bright red Aztec sandstone, but it's remote, on a distant skyline, out of reach. I'm told there's a way to climb from this canyon to a place called Bowl of Fire, where the reds are brighter still. Here in Lovell Wash, washed-out pink mixes with twists and swirls of light orange and cream. Brown fossilized mudpots mark the left-hand walls—one more indication of past activity in this place. The once-flat mudpots now

Light streams through the eroding mudstone walls of Cathedral Gorge.

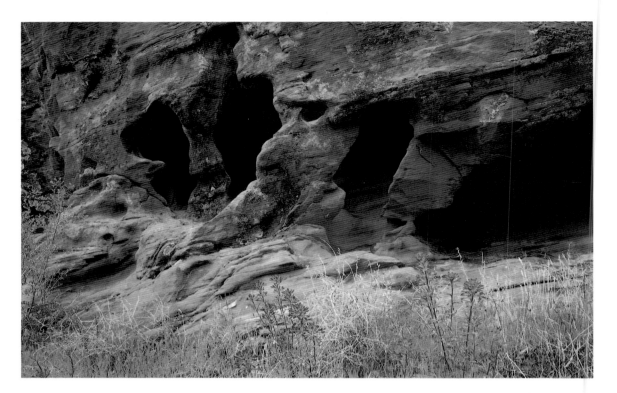

Indian paintbrush against the eroded wall of the Calico Hills, Red Rock Canyon.

hang perpendicularly, uplifted there by some past geological event. Their perfectly round shapes look artificial, as if a powerful potter had thrown circles in stone. Off to the sides, upthrust rocks take the shape and color of split cedar. I'm reminded of layered bark and knotholes and grainy cedar shingles on a scale a hundred times bigger than a Pacific Northwest tree.

Dazzled by the dimensions, I wasn't prepared for the sudden intimacy of the narrows just ahead. One minute I walked in full sunlight along the bottom of a broad wash; the next, I was enclosed in shadowy mother-of-pearl. Try to imagine a waterslide nearly half a mile long, less than six feet wide, with slick sides more than a hundred feet high. Worn by countless flash floods, the waterslide is a summer luge that spirals through the rocks. Looking closely, I see how the sides once fit together. Layers match, so that the lime and apricot marbling on one side repeats itself on the other like a three-dimensional jigsaw puzzle. For some reason, the green pieces match the best.

Uneasily, I examine cracks caused by centuries of water pressure and the tumbling of stones end over end. When the sun passes behind a cloud, I think of the turgid action a rainstorm could generate. Picturing myself slaloming down the narrows, I can't help but look for a way to bail out. A few escape hatches corkscrew up the walls. I've walked through slotted canyons where no exit would have been possible, but this one has several places where I could safely ride out a flash flood. Green plants cling to some of the tiered

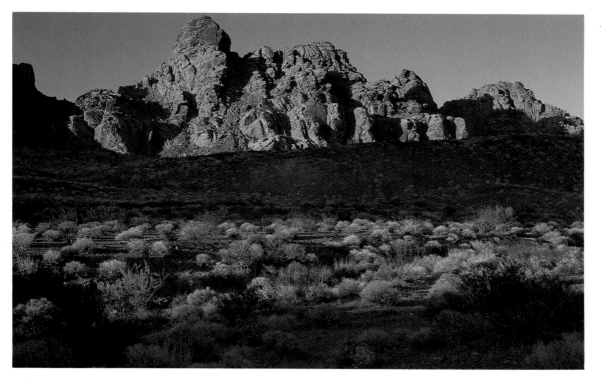

ledges and little lizards dart everywhere, so I'm fairly certain the water level wouldn't reach as high as I could climb. Thinking realistically, though, I doubt I have the nerve to sit calmly above a twenty-foot wave of water. For me it's better to wander up and down Lovell Narrows on a sunny day when I can take my time, sit a while in the narrowest parts, and forget about the clouds.

Warm colors press the walls inward. An artist's vocabulary says that hue distinguishes one color from another, that value determines the range of light and dark, and that saturation defines the relative purity of color on a scale from bright to dull. In Lovell Narrows, the colors closest to me have gemlike hues—mother-of-pearl, nacre, oyster, alabaster, pale amethyst, light emerald, and jade. Though every color looks pure, the paleness suggests a lack of saturation, with very light values. Nothing appears washed out; rather, the walls glow internally. I'm reminded of the ocean, and imagine myself spiraled inside a triton's shell.

The farther I walk up the narrows, the more intense the values. I find one place where darker red marbling clots the paler pink stones, as though a blood sacrifice had been made a millennium ago. I find another where what looks like a gray-black elephant's foot has been trapped. Though the slot doesn't widen, its hues and values deepen. When the walls finally open up, iron oxide and desert varnish saturate the cliffs. I imagine jasper, coral, ruby, onyx, obsidian, ebony, while up ahead I see the Muddy

Mountains defined by tones of brown. The term "earth art" is sometimes used to describe the way a landscape painter rearranges the scenery. Meandering beyond Lovell Narrows, I think about the way a writer chooses earth tones instead. A few steps farther, where oranges and tangerines vanish into dirt tones of khaki and tan, I need to test my own vocabulary. What words describe saturated hues of brown?

Another Rainbow Canyon lies a hundred miles north of the one near Lake Mead. Composed of tuff—solidified volcanic ash—and stained by minerals such as manganese and copper, the cliffs of Lincoln County's Rainbow Canyon flake black and blue and green and red and gold. Some of the tuff looks almost frothy, like rock-solid meringue. Other walls tower in cliff cathedrals, imaginary counterparts to neighboring Cathedral Gorge. A freshwater lake once filled a caldera in the Panaca Valley. When that water escaped—perhaps a million years ago—it created this Rainbow Canyon by carving its way toward the Colorado River, and it left behind the sediments that we now call Cathedral Gorge. Though the two colorful areas are just a few miles apart and though the same ancient water was responsible for designing both places, the geologic histories of the two are totally different. The colors and shapes differ radically, too.

Cathedral Gorge can best be called badlands terrain. Its formations, composed of tightly packed silt and sand, are held together by a weak cement that softens when it rains. What feels lacquered and impenetrable in dry weather becomes porous and muddy in wet. Cuts deepen, cliffs recede, and the formations actually change shape during seasonal storms. I can remember being there in a dissolving shower many years ago, when the glue literally disintegrated underfoot. Evaporation, cycles of freezing and thawing, heat expansion and contraction, and even the wind can cause changes as well. The different stages of erosion are most apparent on the east side of the gorge, where weather touches the walls most directly.

Unlike the cliffs of either Rainbow Canyon, Cathedral Gorge has eroded into clusters of figures, chess sets, salt and pepper shakers, mobs of monks, royal kings and queens. It would be impossible to count the number of individuals, for they stand as close together as you might find in a rush-hour train station. Wedging myself alongside them, weaving among their bodies and getting lost in the crowd, I examine their misshapen garb. No two figures look alike. Connected here and there by natural caprock bridges, undermined by cracks and caves, the wrinkled men and women line the perimeter of the historic caldera and wait for the next storm.

Where the weather has had more time to do its work, the figures have lost their distinctive shapes. Some gather like gigantic pipe organs or organ pipe cactus; others, more sharp-tipped and spiked, together resemble some science fiction terrain. Separate

groups make icebergs marooned in the sand. With still more action from water and wind, the bergs and spikes disintegrate into nubbined caricatures of themselves. Their spires and angles disappear until finally they flatten into mounds covered with crypto-biotic soil. This black, crusty combination of dirt, silt, algae, mosses, fungi, bacteria, and lichens stabilizes the mounds and temporarily halts the wearing away. A single footstep restarts the cycle, however, making the earth vulnerable to erosion once again. A new four-mile loop trail in the state park, steering visitors away from the most fragile places, keeps the foot traffic from accelerating the damage.

Throughout most of the Southwest, sculptured rocks and mineral-enhanced colors are inseparable. When I think of the Grand Canyon, for example, I picture the tones and hues as well as the designs of the formations. Looking at Cathedral Gorge, however, I'm impressed more by the shapes than the shades. Though Cathedral Gorge boasts subtle differentiations of pink and cream, tawny bands of light and lighter, I focus on the shrouded figures and the way they group together. I'm struck by balance, rhythm, tex-ture, geometry, continuity and design, by shadows contouring the shapes. Drab at noon-time, the figures are cloaked in mysterious folds at either dawn or dusk. Night shadows give them somewhat darker hues, but no one would mistake this landscape for a deeply saturated place. Color just doesn't dominate the senses here.

Nor does the name "Cathedral Gorge" seem quite right. Disliking the original "Panaca Gulch," a local resident named Mrs. Godbe wanted to rename the valley be-cause she found the formations awe-inspiring. Her new designation became official in 1895. But the eroding shapes don't look especially churchlike to me, even though I can imagine thousands of parishioners massed together in prayer. How we choose to name a place says something about how we perceive a landscape. For Mrs. Godbe, Cathedral Gorge was a kind of sanctuary, a saintly valley where she rode horseback among the pale formations and felt intimacy with the silent figures. I can't help but compare her sense of this valley with Valley of Fire, another state park in southeastern Nevada. Cathedral Gorge chimes ethereal; Valley of Fire rings more powerful, larger, more diabolical.

The blush reds and oranges in Valley of Fire are darkly vital, their Elephant Rock formations grandiose. One night, camped close to the prosaically named Poodle Rock, I walked around and around the immense doglike figure. Closure—the tendency for the eye to perceive an incomplete figure as complete—is important to any sculpture, for it forces the viewer to finish a figure imaginatively. Closure inadvertently happens when I look at a giant formation like Poodle Rock. Its shape becomes an actual dog, complete with muff and open mouth, one ear sheared off, fringed fur, an alert eye guarding a bone carved in stone. Both larger and darker red than the surrounding rocks, the make-believe

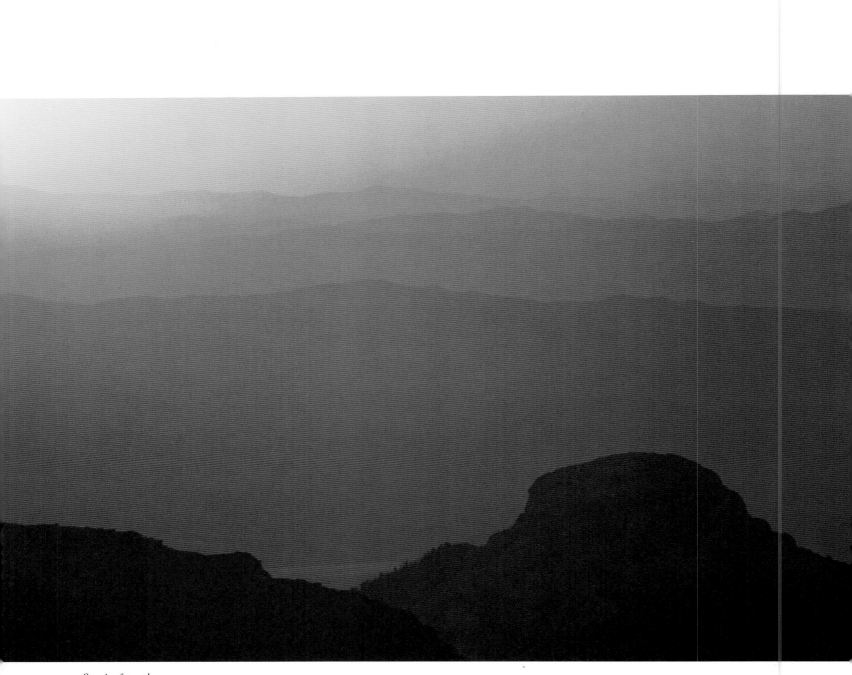

Sunrise from the Snake Range, basins and ranges awash in light.

poodle stands out against its background. No single Cathedral Gorge figure dominates its fellows so completely.

A few miles beyond the Valley of Fire Visitor Center arches still another rainbow—Rainbow Vista, where the park brochure announces "a favorite photo point with a panoramic view of multi-colored sandstone." There, lacquered reds and oranges stain the monolithic walls in ways tourists expect in the Southwest. I like to go beyond the viewpoint, where cars no longer are allowed but where hikers are welcome. One summer day I followed the abandoned roadway to the right for a while, then left the dirt track and wandered up Fire Canyon. Like so many wine-stained washes, it surrounded me with a flush of color that matched the temperature. I clambered over sandstone slides, touched the prismatic reds, and felt the hundred-degree heat radiate from the rocks. I remember drinking all the water I carried in my daypack and wishing for more.

Hiking the other direction from Rainbow Vista, I ambled past pale blocks toward the ashen beehives of the White Domes. White rocks glare in a noon sun, but seem less furnacelike and less stifling than red. I traversed several miles of milk and cream, then stumbled on a ghost town, or so I thought. Some wood pilings, a stone facade, perhaps a gallows, not much else. I couldn't remember reading about any such historic site, so I stopped back at the Visitor Center to ask about the place. Ghostly remains, yes; a ghost town, no. I had discovered a movie set built for a 1966 western, *The Professionals*. Later I rented the film and watched Lee Marvin, Burt Lancaster, Robert Ryan, Woody Strode, Jack Palance, Ralph Bellamy, and Claudia Cardinale weave illicit passion with Mexican politics in Valley of Fire technicolor. A trite script—"I hate the desert, it's got no pity," one character moans—but a good cast and even better scenery.

The last time I went to Valley of Fire, I had another surprise. The sunny flowers drew my attention more than did the colorful rock formations. Springtime is flower time in the desert, especially when just the right combination of water and then warmth produces a florist's array. Low to the ground, golden marigolds and saffron fire needle fetid and poppies and lemon-yellow daisies dotted the red earth. Yellow creosote, a normally unexceptional bush, seemed to be everywhere. Brittlebush is another bright yellow shrub that profusely colored this spring landscape, and there was blackbrush, a canary member of the rose family. Driving into Valley of Fire, I usually concentrate on the rocks. But when shades of gold line the roadside, the contrast between the primary colors is remarkable. The red rock looks deeper; the afternoon sky, bluer; the yellow flowers, aglow.

Several years ago I hiked up Kaolin Wash northeast of the visitor center. When I started out in the early morning, I saw only a few partially open blossoms here and there.

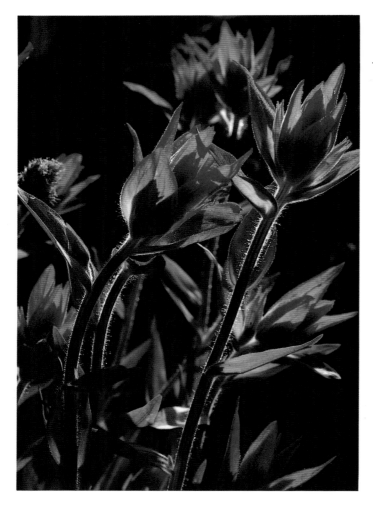

Indian paintbrush,
Emerald Lake,
Jarbidge Wilderness.

By the time I returned in midafternoon, yellow sunflowers and paperflowers and gold-enweed and brittlebush and creosote covered the hillside between the truck and the wash. In just a few hours the desert had gilded itself. While April brings more splashy yellow than any other color, I have found lots of purple blossoms too. Some grow from oddly alien plants, such as the notch-leaf phacelia, a stinkweed that acts like poison ivy on the skin. The bladder bush, or paperbag bush, simultaneously shows off attractive purple flowers and unfriendly gray stickers. Other shades of purple burst from bushy indigo, mojave aster, blue desert larkspur, and lavender puffs of mint.

I like combinations of beauty and brashness, blossoms and protective spikes poking from the same branch—the catclaw acacia, or tearblanket, for example. Indian people ground the seeds into meal, then used the meal for mush or cakes. Its fuzzy pale yellow flowers provide an important source of nectar for honeybees. But getting caught by cat's-claw thorns is painfully annoying—diabolical, one might say. Hikers call it the "wait-

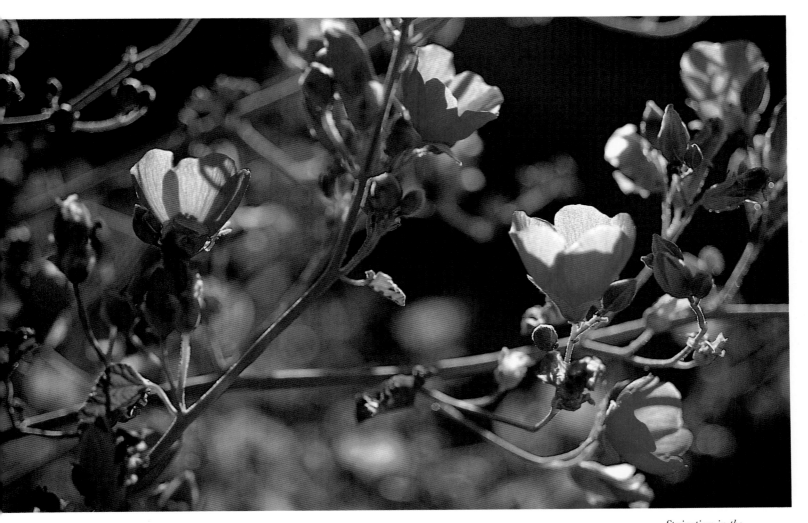

Springtime in the Mojave Desert, globe mallow blossoming under Joshua trees.

a-minute" bush because it catches the unwary and stops them in their tracks. I prefer such down-to-earth designations instead of scientific terminology. For one thing, the words are easier to remember; for another, common names often sound poignantly appropriate. Cat's-claw. Tearblanket. Devilsclaw. Bearclaw poppies. Prince's plume. Globe mallow. Spurge. Peppergrass. Fiddleneck. Trumpet flower. Scorpionweed. Thornbush. Lemonade berry. Desert almond. Desert tobacco. Parachute flower. Broomrape. Bladderstem. Turpentine bush. Cheesebush. Cholla. Prickly pear. Hedgehog. Yucca.

Cactus especially pleases me. Again, it's that juxtaposition of sharp spines and colorful flowers. A small cactus can hide behind other angular plants and barbed shrubs, so bright cactus blooms surprise me. A single prickly pear may have two dozen or more fuchsia flowers, shocking pink–purple corollas, vibrant, showy. Last spring I chanced upon an exceptional hedgehog cactus, its bright orange-red petals shading into yellow centers, its stamen green with filaments of pollen, its stems and aureoles heavy with the

weight of twenty flowers. Perfection, I thought—until ten feet away I saw a creamy yucca in full bloom.

Thanks to *Arizona Highways*, everyone expects such displays in the Sonoran and Mojave Deserts. The Great Basin grows flowers too, but like its sporadic Neapolitan ice cream canyons, the northern desert's flowers get less attention than their neighbors to the south. Many of them are tiny belly flowers no larger than a pinhead or the tip of a fingernail. I can find dozens of them in shades of white and yellow, pink and purple, but they are impossible to see unless I'm on foot. They're just too small. Larger floral displays are easier to spot, especially those—like Indian paintbrush—in shades of red and orange. My favorite high desert flower is the lupine, which grows along the flanks of the ranges. After a particularly wet winter, I saw the northeastern steppes of Jarbidge totally covered with nodding lemon lupine—as far as I could see, foot-high plants only a few inches apart, waving like a pale golden sea. Even Peavine, the mountain just northwest of Reno, was swathed with long lupine folds that year.

Because it's just outside my door, I walk on Peavine regularly; and because I go there so often, I stay in touch with the seasons. After heavy snowfalls in 1986, and again in 1993, the mountainside came alive with flowers. Every two weeks the entire floral display would change, from inch-high purple Johnny-jump-ups to white and pale lavender lupine to clover and blue larkspur to orange globe mallow and flowering peach to mule's ears and California poppies. Even the dandelions looked lush. Given the winds of spring, I effortlessly raise wildflowers in my own backyard—more barbed yellow blazingstars than dandelions, believe it or not. Except high on the mountainside, Peavine has few trees, so even though its changing display of flowers may last for a couple of months, its slopes shade green for just a week or two. Then summer-brown takes over until fall, when the golden rabbitbrush and sagebrush pollen make hay fever sufferers miserable. Only in winter white does Peavine ever look glamorous—unless you walk its slopes and pay close attention to its seasonal nursery.

The Great Basin is a place where most of the colorful blooms occur in the spring, especially on south-facing hillsides after the snow melts or along riparian zones. Sometimes the growth is massive in size, effusive yet pale. East of Tonopah I sat beside a Fang Ridge cliffrose thicket where every gnarled branch was thickly covered with creamy flowers, and bees. The five-petaled flowers with golden centers looked like tiny wild roses, though they smelled more like orange blossoms. The bushes, six or seven feet high, grew so close together that I couldn't even make my way to the streambed. It's easy to confuse cliffrose with bitterbrush or antelope brush, a yellow cousin with less conspicuous flowers, more intricate branches, and seeds that aren't plumed. One or the

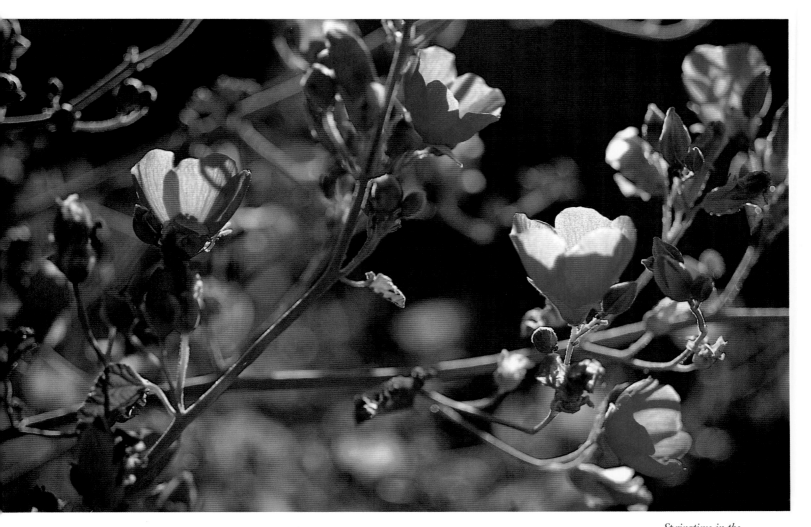

Springtime in the Mojave Desert, globe mallow blossoming under Joshua trees.

a-minute" bush because it catches the unwary and stops them in their tracks. I prefer such down-to-earth designations instead of scientific terminology. For one thing, the words are easier to remember; for another, common names often sound poignantly appropriate. Cat's-claw. Tearblanket. Devilsclaw. Bearclaw poppies. Prince's plume. Globe mallow. Spurge. Peppergrass. Fiddleneck. Trumpet flower. Scorpionweed. Thornbush. Lemonade berry. Desert almond. Desert tobacco. Parachute flower. Broomrape. Bladderstem. Turpentine bush. Cheesebush. Cholla. Prickly pear. Hedgehog. Yucca.

Cactus especially pleases me. Again, it's that juxtaposition of sharp spines and colorful flowers. A small cactus can hide behind other angular plants and barbed shrubs, so bright cactus blooms surprise me. A single prickly pear may have two dozen or more fuchsia flowers, shocking pink–purple corollas, vibrant, showy. Last spring I chanced upon an exceptional hedgehog cactus, its bright orange-red petals shading into yellow centers, its stamen green with filaments of pollen, its stems and aureoles heavy with the

weight of twenty flowers. Perfection, I thought—until ten feet away I saw a creamy yucca in full bloom.

Thanks to *Arizona Highways*, everyone expects such displays in the Sonoran and Mojave Deserts. The Great Basin grows flowers too, but like its sporadic Neapolitan ice cream canyons, the northern desert's flowers get less attention than their neighbors to the south. Many of them are tiny belly flowers no larger than a pinhead or the tip of a fingernail. I can find dozens of them in shades of white and yellow, pink and purple, but they are impossible to see unless I'm on foot. They're just too small. Larger floral displays are easier to spot, especially those—like Indian paintbrush—in shades of red and orange. My favorite high desert flower is the lupine, which grows along the flanks of the ranges. After a particularly wet winter, I saw the northeastern steppes of Jarbidge totally covered with nodding lemon lupine—as far as I could see, foot-high plants only a few inches apart, waving like a pale golden sea. Even Peavine, the mountain just northwest of Reno, was swathed with long lupine folds that year.

Because it's just outside my door, I walk on Peavine regularly; and because I go there so often, I stay in touch with the seasons. After heavy snowfalls in 1986, and again in 1993, the mountainside came alive with flowers. Every two weeks the entire floral display would change, from inch-high purple Johnny-jump-ups to white and pale lavender lupine to clover and blue larkspur to orange globe mallow and flowering peach to mule's ears and California poppies. Even the dandelions looked lush. Given the winds of spring, I effortlessly raise wildflowers in my own backyard—more barbed yellow blazingstars than dandelions, believe it or not. Except high on the mountainside, Peavine has few trees, so even though its changing display of flowers may last for a couple of months, its slopes shade green for just a week or two. Then summer-brown takes over until fall, when the golden rabbitbrush and sagebrush pollen make hay fever sufferers miserable. Only in winter white does Peavine ever look glamorous—unless you walk its slopes and pay close attention to its seasonal nursery.

The Great Basin is a place where most of the colorful blooms occur in the spring, especially on south-facing hillsides after the snow melts or along riparian zones. Sometimes the growth is massive in size, effusive yet pale. East of Tonopah I sat beside a Fang Ridge cliffrose thicket where every gnarled branch was thickly covered with creamy flowers, and bees. The five-petaled flowers with golden centers looked like tiny wild roses, though they smelled more like orange blossoms. The bushes, six or seven feet high, grew so close together that I couldn't even make my way to the streambed. It's easy to confuse cliffrose with bitterbrush or antelope brush, a yellow cousin with less conspicuous flowers, more intricate branches, and seeds that aren't plumed. One or the

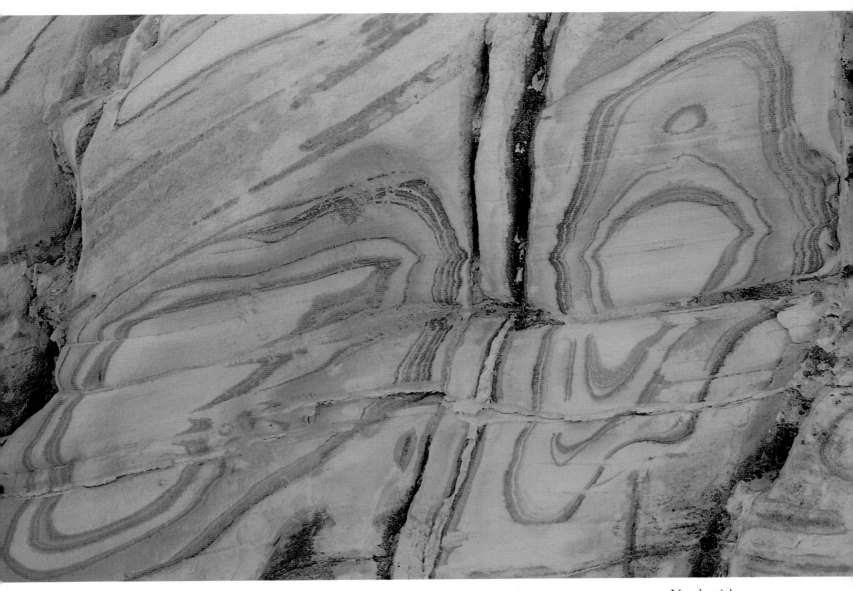

*Nevada rainbows
captured by mineral
pigment, Muddy
Mountains.*

other seems to dominate sunny riparian sidehills all across central Nevada. Neither is easily negotiated.

Two days after I smelled the orange scent of the cliffroses, and just a range away, I hiked through a wild serviceberry grove that reminded me of Washington, D.C., at cherry blossom time. The flowers clustered white instead of cherry-pink, but the rugged trail traced an orchard path and petals dropped softly across my shoulders. Gradually I slanted up a sidehill, leaving the serviceberries behind and climbing toward a set of grassy lakes tucked near the crest of the Kawich Range. Some years there are several Bellehelen Lakes; some years, only a puddle or two. Winter snowmelt dictates the water depth and the extent to which the ponds are drying into meadows. When I was there, water covered most of the grass. Hiking past the lakes, I had to step carefully across rivulets, through bogs, and in and out of mud. Storm-black clouds lifted overhead, while flatter lenticular shapes spun toward the horizon. Wind whipped miniature whitecaps in the shallow water.

Just as an artist would prepare a background by lightly brushing paper with water and a little paint, so any Nevada landscape looks awash in different lights. Dark blues and purples come with shadowy sunsets, especially when a storm blows from the north. Enough dust particles, and an evening sky stains darkly copper, terra cotta, rust. Lighter blues and lavenders wash in with winter, in early morning after a fresh snow. The lushness of spring doesn't last long, yet an April rain glistens the desert green for a day or two. Dry tans and browns signal summer, and the basins glare white on a scorching afternoon. Rabbitbrush and aspengold fade into fall, until the cycle repeats itself.

A dusty rose washed the Bellehelen landscape that June day, an off-color setting, one tainted gray where the clouds dipped close to earth and tinged oddly pink beyond the lakes to the east. The farther I walked, the more I imagined myself transported to Canyonlands' Chesler Park. Beyond Bellehelen Lakes and below Kawich Peak, a high, flat bowl perhaps half a mile across holds pale red slabs and folds and beehives and gargoyles. Hunched blocks and spirit shapes guard an escarpment where the edge of this Nevada park drops straight off. To get there, I wandered through a labyrinth of ghoul walls, braille-carved by erosion and pockmarked by time. I was miles away from other varnished rock, half a state away from a painted valley or bowl of fire. Yet I was surrounded by rain-streaked color—melon hues and rich iron values, saturation. Another earthtone setting, I thought, as I explored the prismatic recesses and sheltered myself from the wind. Another unexpected Nevada rainbow.

Water

Nevada state climatologist John James tells me that the term "average annual rainfall" is misleading in Nevada. While precipitation in the Silver State may average nine inches each year, that precipitation does not arrive in ways a Pacific Northwesterner might expect. Nevada receives no gentle rains spread over a season or a full twelve months. Instead, according to James, Nevada's basins and ranges receive episodes.

The dictionary defines the word "episode" in telling ways. An episode is an incident that is complete in itself. Or, an episode may be an event complete in itself but part of a larger whole—an installment in a drama, for example. The word, aptly enough, originated as a designation for the part of an ancient Greek tragedy between two choric songs. While I don't mean to imply that Nevada's weather episodes are necessarily tragic,

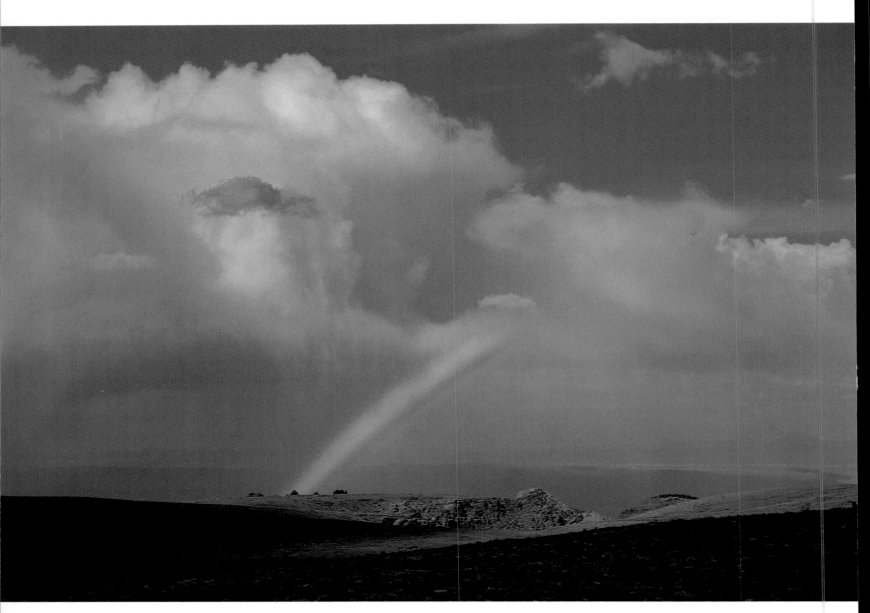

An episodic summer thundershower over Mount Moriah in the Snake Range.

I do mean to suggest that they often present a kind of climactic explosion in the midst of relative calm. A number of such energetic—and often startling—weather bursts comprise Nevada's average annual rainfall.

The Las Vegas area offers some stunning episodic examples. The only time I have seen the front of a flash flood begin its rampage occurred in the midst of an episode in this ordinarily dry desert country. It happened in March, twice. Camped beside a wash in Valley of Fire, high enough to be safe yet close enough to have a decent view, I sat and waited. Rain had deluged the park all week long, so the red earth was soggy and saturated. Already at least one flash flood had caromed down this particular canyon—I could see where the motion had churned and receded—but the water hadn't risen far or done much damage. Given the current downpour, I assumed another flood would follow soon. It did.

It looked just like the descriptions I've read in books, a cauldron of roiling tomato soup spilling, fast. Caught in its lip, foam and sage and rocks turned upside down. Not as loud as a freight train, for my flood wasn't an especially large one, a guttural undertone nonetheless could be heard. As the water rose, I could see its power cutting banks where no banks had been before and pulling up bushes that had been growing for years. A hundred red waterfalls spewed off the high canyon walls, all feeding this little nameless wash that was on its way to becoming a river. The deeper the water, the larger the debris swept along by the force. Since the rain, though violent, was intermittent, the torrent fortunately wore itself out before it got too close. When the rains returned, however, the flood waters reappeared too.

The truck was never in any real danger, but I must admit that I fretted when the curving cut of the ever-deepening wash came closer and closer to where I had parked. Though I didn't move the truck that night, I thought about it a lot. Between twilight and dawn, I woke myself up a dozen times. The next morning, the truck still safely anchored, I investigated. Only a zigzag line of damp sand, sporadic piles of torn brush, some upended red rocks, and swirls of thickening mud marked the way of the water. First I walked up the canyon to examine the steaming, drying walls where the watercourse began. Then I followed the water's path—a trail of sucking quicksand in many places—down beyond my campsite to where the wash had careened alongside a cliff, chewed through a dirt road, and then dispersed harmlessly onto an open flat. Strolling the canyon today, half a dozen years later, I can hardly imagine the long-receded turbulence. Creosote has taken hold of the watercourse, and tourist footprints powder red dirt that looks like it's been dry for decades.

My Valley of Fire flash flood was by no means tragic or even traumatic, but episodes often are. After the storm, Las Vegas newspapers told stories of flooded streets, drowning underpasses, cars and people caught in the churning water. By then, however, bright sunshine gave an illusion of serenity and peace. The torrent I saw was a true episode in John James's sense of the word, an incident complete in itself but part of a larger pattern of rainfall and aridity. Only in dry desert country do flash floods so violently burst forth and then so quickly, so gently recede. A handful of such episodes, added together, total that meaningless statistic used by weather forecasters and their followers eager for facts on which to lean—average annual rainfall. Unabated aridity in Nevada is a kind of myth perpetuated by those who don't live in the desert. While ninety-nine days out of a hundred may bake under a burning sun, that hundredth day can offer up an unexpected episode.

A flash flood is one kind of episodic event; an off-season blizzard is another. The Las Vegas area is too far south for wintry surprises in summer, but the northern tier of the state can receive snow during any month of the year, snow that may be bracketed by summer days of eighty-degree temperatures. There is nothing more schizophrenic than setting out on a camping trip wearing shorts and T-shirt, then ending the outing in a blinding snowstorm. Backpacking in the Clan Alpines in June, when I was younger and more naive, I once woke to find my boots completely filled with snow. I didn't even have a pair of long pants to protect my legs on the slippery hike down out of the range.

I'm slightly smarter now, but no less astonished when summer skies begin to churn blackish-gray and sudden north winds drop a temperature more than a dozen degrees in just a few minutes. That's when a wise camper eats a hasty meal, goes to bed early, turns her boots upside down—or brings them inside the tent—and waits. One such episode in the Schell Creek Range outside of Ely changed July into a veritable winter wonderland. Since the Schells are the fourth-highest range in Nevada, I might have expected something. After setting up camp along Timber Creek and donning layers of extra clothes, I watched afternoon storm clouds build massively to the west. I cooked supper in a cold rain. Sometime that night, the temperature dropped lower still and the rain gave way to snow.

I planned to climb North Schell, a rather gentle 11,883-foot peak whose July slopes normally are covered with clusters of purple heather, green lichen, wild buckwheat, and thousands of tiny phlox. The elk transplanted to the Schells more than half a century ago often graze just below the crests and offer special entertainment to humans hiking nearby. From the top of North Schell, the highest mountain in the range but one of the easiest climbs—nothing more than a long walk, really—the panorama swings 360 de-

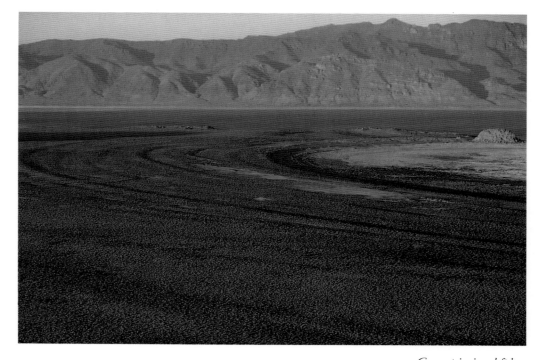

Concentric rings left by the receding shoreline of Pyramid Lake.

grees. On a clear summer day, I've seen Wheeler Peak and Moriah to the southeast, Ward Mountain and the mine at Ruth to the southwest, basins and ranges beyond and even the Ruby Mountains far to the north. Best of all, few other hikers clutter the view. The register on top once told me in late June that I was the first person to make the ascent since the previous September.

Another July, another story, however. That episode buried the route to the summit in a whiteout so thick that at times I couldn't see more than half a dozen feet. Wisely, I didn't go as far as the exposed ridges, but I did wander up Timber Creek for a couple of miles. The thick sloppy white stuff stood nearly knee-deep, the young aspen bent sideways with the weight. At intervals, red Indian paintbrush stuck up through the snow, like Christmas ornaments out of season. Neither elk nor deer could be seen, though birds everywhere twittered disbelief at what July had precipitated.

I didn't reach the top of North Schell that year, just as I didn't challenge Mount Augusta in the Clan Alpines so many years earlier, just as I didn't climb Tohakum one April Sunday when, standing beside Pyramid Lake, I watched a disorienting snowburst hide the shoreline only two feet away. It's impossible to live in Nevada without experiencing episodes now and again, explosive and potentially tragic wet interludes in the midst of ongoing aridity, regular irregular climactic events. Anyone who spends time exploring the Silver State quickly learns to follow the Boy Scout motto and to expect the unexpected.

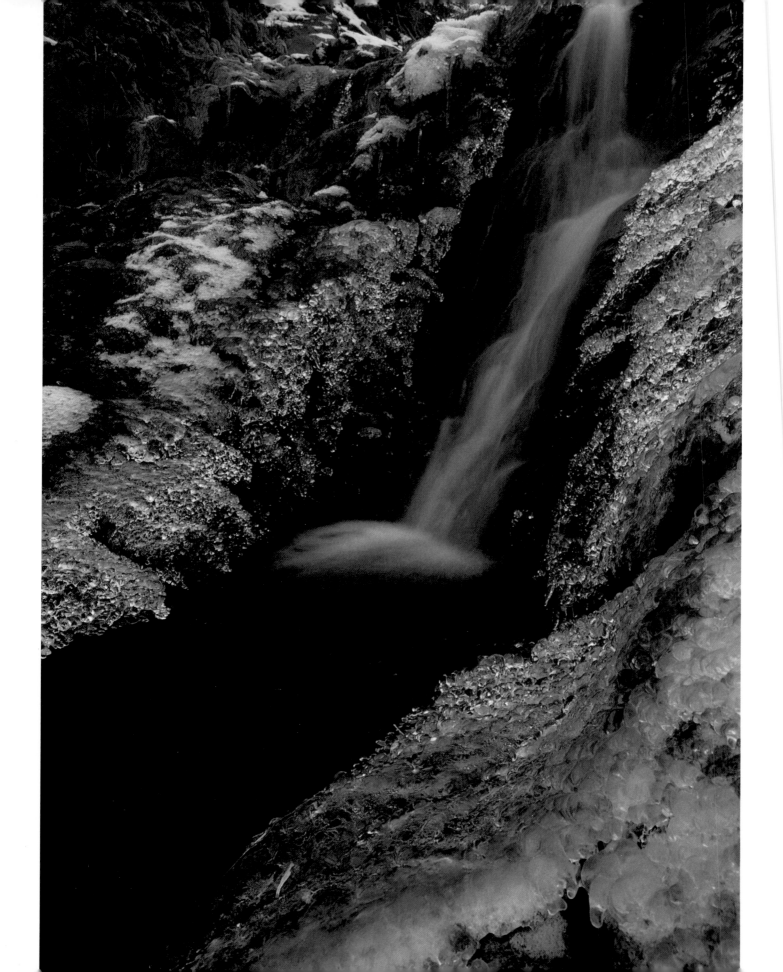

While episodes provide the most dramatic sources of water in a desert landscape, they're not the only ones. Visitors rightly assume there has to be some explanation for the numbers of boats seen trailering along through the sand and sage. Some of the marina activity takes place in a mountain setting so familiar I hesitate to describe it one more time. I do claim half of Lake Tahoe for Nevada, but I'm leaving its picturesque shores to those essayists who favor green and blue. At the opposite end of the state, aquatic enthusiasts flock to a man-made locale. Hoover Dam, built in the 1930s, generated a lake that looks today as though it had always been there. Massive Lake Mead, all nine hundred trillion gallons of it, boasts an artificial shoreline of some 822 miles. Over the years it has developed into a very real desert oasis that attracts countless sunbathers, swimmers, divers, boaters, windsurfers, anglers, and trollers. The dam designers would be proud, but their accomplishment still seems alien to me. I prefer a more natural ebb and flow.

Pyramid Lake is home to the Paiute Indian people. The tribal fishing guide waxes poetic:

> A remnant of the colossal glacial Lake Lahontan, Pyramid Lake is about 25 miles long, up to 11 miles wide, has a surface area of about 115,000 acres and is more than 300 feet at its deepest. The lake is almost a shock when seen for the first time. Often a deep azure or brilliant turquoise blue surrounded by subtle pastel mountains in shades of lavender-grey and soft spice, it exudes a profound sense of antiquity. Its beauty is almost supernatural, and it is never the same color twice.

The brochure's colorful description quite literally is true. Pyramid's brilliant green-blue-turquoise does change from moment to moment, an azure emerald set in khaki brown. The lake sits alone in a desert devoid of casinos, condominiums, cabins, or even trees. Seeing it unexpectedly—and, since the main route from Reno crests sharply over a hill, one always sees it unexpectedly—a newcomer must feel as if the car had mysteriously arrived on another planet. The pyramid-shaped rock that gives the lake its name, nearby Anaho Island covered with nesting birds, and the porous limestone tufa formations rimming the north shore provide the only distinctive features in an otherwise barren view. Sometimes Pyramid calls for lean adjectives and cold nouns instead of romantic pastel phrases. It can be a dangerous place, where sudden squalls blow without warning and temperatures swing sixty degrees in a day. Or, as the brochure hints, the lake can be soft spice enchanting.

A Pennsylvania friend, caught in an apparently never-ending winter, wrote and asked if Nevada were warmer, if Pyramid had begun to thaw. I laughed at his question,

Winter in the desert; an icicle waterfall on the slopes of King Lear Peak, Jackson Mountains.

and wrote back that I had just spent a February day near the Needles, lounging in my shirtsleeves on Pyramid's iceless shore. I had driven to the far end of the lake to see up close the tufa peaks and spires that resemble fairy castles from a distance. I can imagine Dorothy dancing toward them, following a yellow dirt road instead of a yellow brick one. Near at hand, however, the Needles lose some of their magic. The building blocks are mudpies and popcorn balls with an underlay of honeycombs and an overlay of scabs— playdough writ large. At noon, especially in winter when everything is the same color, the formations are brown, brown, brown. Nothing glitters, nothing shimmers, nothing resembles the Emerald City at all.

Nonetheless, there is something special about the place. The hot springs that bubble up beyond Wizard Cove are a shaman's delight. Though captured by twentieth-century pipes, the mineralized water spews into the air and then, like a geyser, vaporizes higher still. Hot tub aficionados have dug channels and bathtubs to capture the overflow. One such tub lined with rocks actually sits in Pyramid Lake, so that the steaming and the chilly waters mix—a Scandinavian sauna crossed with a Native American sweat bath, Nevada style. The view from the tub is spectacular—the full length of the lake in one direction, a row of tufa gargoyles in the other, voodoo sorcery in the air.

A tufa bathtub ring reminds the viewer of reality. When John Frémont first saw Pyramid in 1844, the lakeshore was more than seventy feet higher than its 1994 level. Genetically unique cutthroat trout weighing as much as thirty or forty pounds and the prehistoric cui-ui—a sucker left over from the Ice Age—swam in Pyramid's waters. The lake was an Indian smorgasbord. Thinking little about the Paiute people who lived there and even less about the fish themselves, state and federal governments in partnership created what was to be a model for water redistribution in the West. Finished in 1905, the Newlands Reclamation Project diverted half of the Truckee River water to farmers thirty miles away. In doing so, the Bureau of Reclamation diminished the lake's only major feeder stream and set in motion a process that, if left unchecked, would eventually have killed Pyramid Lake.

What was done to Pyramid Lake in Nevada differs in no significant way from what was done throughout the West during the first part of the twentieth century, when progressive thinkers gave engineers a green light to drive agricultural and economic development forward. Now, of course, we better understand the consequences. Diverting water from one drainage to another can cause real problems—destroying the Lahontan cutthroat spawning beds, in this case, and endangering nearby pelican nesting grounds by dropping Pyramid to an unnatural level. When the Newlands Project was set in motion, however, no one stopped to worry about the long-range impact. Nearly a

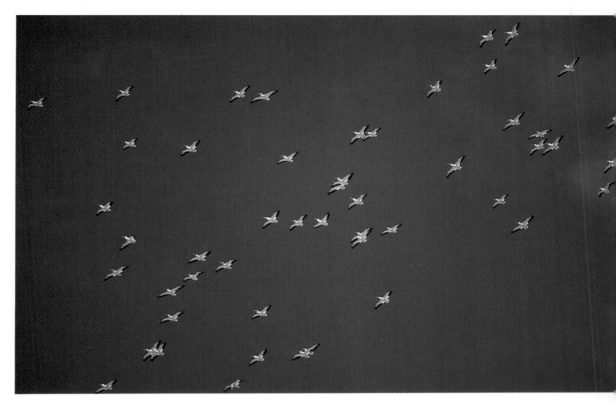

Pelicans at Pyramid Lake, wings lifted against the wind.

hundred years later, everyone cares—the Paiute people, the Fallon farmers, the cities of Reno and Sparks located upstream on the Truckee, various branches of state and federal government, elected officials, and citizen watchdog groups.

With the involvement of the courts and Congress, bitterly fought compromises protecting the fish and some of the rights of the Pyramid Lake Paiute Tribe have been reached. On the one hand, such settlements have no effect on the unsightly white rings that now mark the tufa, Anaho Island, and the pyramid rock itself. On the other, the lake's integrity has been preserved, for a while. During our lifetimes, at least, we will continue to see boats pulled through the desert by eager anglers on their way to a still-viable Pyramid. Hatchery trout may not be quite the same as their free-breeding ancestors, but today a twenty-seven-inch cutthroat is not unusual. A trophy sport fish may be the lure for some visitors, but the pelicans are an enticement for others.

Pelicans are surprisingly big birds, with wingspans as wide as eight feet. White, with bright orange-gold bills and black coloring beneath their wings, they look regal when they fly. In springtime literally hundreds of these monarchs nest on Anaho Island, hatching as many as 1,500 fledglings each year. Anaho, named a national wildlife refuge in 1913 and still protected today, reputedly is home to the largest pelican colony in North America. Flocks of forty or fifty in flight are a common sight, waltzing together on the wind,

catching the thermals through updrafts and down. When they fly west into the sun, their colors shimmer black, white, and gold. On some unheard signal or special instinct, they turn their backs, flying east, white pearls strung across the sky. They curve back, sway closer, swing away, disappear, reappear, colors reversing from gold coinage to white to gold, wings lifted against the wind. A curtain of northern lights, a drapery of shook foil, a pelican chandelier.

Listed in *Peterson's Field Guide to Western Birds* as seabirds—subcategory "aerialists"—pelicans may be a desert surprise to many people. But they belong at Pyramid as much as the cutthroat or the cui-ui, as much as the loons and the gulls, as much as the deer and coyotes and jackrabbits and even cougar that frequent the nearby hills, as much as the Paiute people who lived in harmony with the lake for hundreds of years before the white man diverted its waters.

Less than a two-hour drive to the south, another desert lake is headed more rapidly, more surely, toward a premature death. Walker Lake, like Pyramid, has no outlet and receives its intake water from only one major source. When that source diminishes, as in recent years when drought has forced ranchers to draw down the upstream water, the lake's very lifeblood evaporates. Not only does the waterline recede, but the saline content increases. Fish die, the lake dies—a natural drying trend accelerated by twentieth-century water practices. Estimates vary, but most predict that within the next decade Walker Lake could be a mud puddle, an eyesore in the midst of desert scenery. Not long ago I sat and watched its colors fade. Gunmetal gray in the direct sunlight, then a flatter green as winds pressed the surface into waves, Walker turned almost purple at its edges. Where the water is shallow, the true emerald tints of a desert lake already are diminished. Before long, I guess, the purple itself will give way to mud and dust.

Resuscitating Walker Lake, with its upstream water allocation of 120 percent, is almost more complicated than saving Pyramid. Since ranchers are not diverting the Walker River to another watershed but are simply exerting the water rights that their families have held for a century or more, there is no simple solution. It isn't easy to go against the law, to find the rights of the lake suddenly more pressing than those of landowners. It would be nice if an explosive summer thunderstorm or a heavy winter's snow could reverse the pattern, but even dozens of such episodes won't suffice. Walker needs a cataclysmic savior now. Otherwise, inevitably, another dried lakebed will dust a future Nevada landscape, until another Ice Age restores the lake to life.

Water is precious in the desert. Its presence or its absence dictates the success or failure of a ranch, the growth or decay of a township, the existence or evaporation of a lake, the life or death of what we now call an ecosystem, the longevity or demise of a

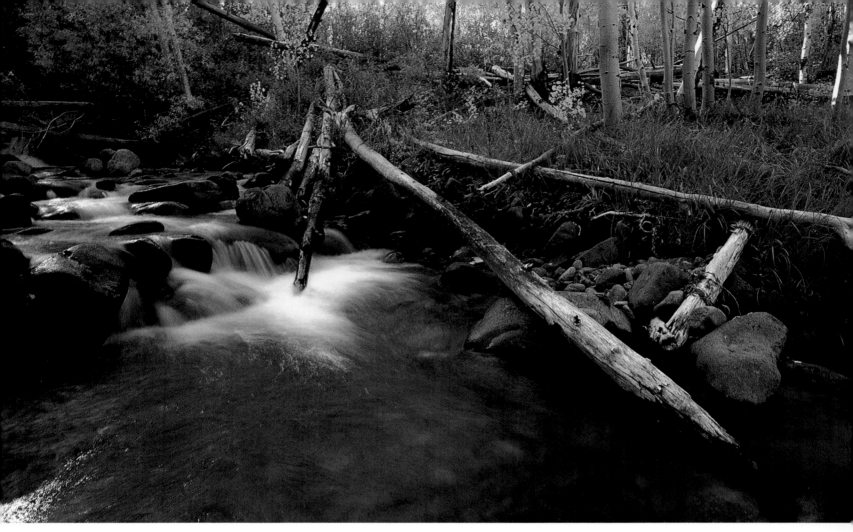

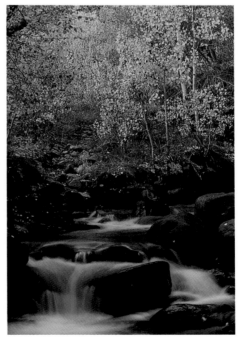

*Aspen along Pine
Creek, Mount Jefferson,
Toquima Range.*

native population. Water is precious, but it isn't a vanishing species. Water does exist in a desert environment, not just in episodes, not just in lakes, but in actual streams and creeks flowing in the ostensibly arid mountains that grid the state. While I'm not talking about major rivers, I do mean appreciable watercourses fed by snowmelt, seeps, and springs.

For example, two year-round streams called Cottonwood Creek and Barley Creek come together in the middle of Nevada about half a gas tank from Austin. Over Petes Summit and then down Monitor Valley on an unpaved road, the foreground is dusty and dry—though once I found the county road crew's tractor sunk above its wheels in mud, and later that day we slithered past Petes Summit in the snow. In July, however, the daytime drive is a scorching one, with temperatures soaring well above ninety degrees. Simply getting to the convergence of those two streams is hot work.

Cottonwood and Barley Creeks mark routes to Table Mountain, a 10,000-foot plateau separating Monitor Valley from Green Monster Canyon to the east. Home to one of the largest elk herds in the state, Table Mountain itself has no water on top. But the creeks that flow down its flanks are noteworthy high desert watercourses. On horseback or on foot, you can make a leisurely loop by climbing up to the table along one drainage, picking a path across the undulating grasses and sage on top, then dropping back down the other side.

The Cottonwood trail reminds me of any one of half a dozen approaches to the eastern Sierra a couple of hundred miles away. Near the water, bushes and grasses mat together in a tangle of greenery punctuated by yellow monkey flowers, firecracker penstemon, and a dozen other summer blooms. When I stopped for lunch, I guessed what the watercourses above Bishop, California, must have looked like a century ago. I poked around in thigh-deep Cottonwood pools, herding Nevada trout with my bare hands. Yet not more than thirty feet away, cactus bloomed and, fifty yards beyond that, piñon-juniper grew against pinnacles of rock. The contrasts between creek and canyonside grew sharper as I walked farther. Near the streambed, damp air keeps a hiker cool, while away from the water the temperature climbs appreciably. I amused myself as I hiked by comparing flowers in and out of the riparian walkway. Finally the trail disintegrated in a tangle of deer paths and byways, broken underbrush and fallen aspen, muddy sloughs created by eager bank beavers who live beside the water. Just when I tired of slapping bushes away, I found a small meander fed by a trickle of snowmelt. So I left the overgrown Cottonwood basin and followed instead the gentler wash to the top of Table Mountain. That cut, covered with damp moss and the mulch of last year's aspen leaves,

The contrast between streambed and canyonside, South Twin River, Toiyabe Range.

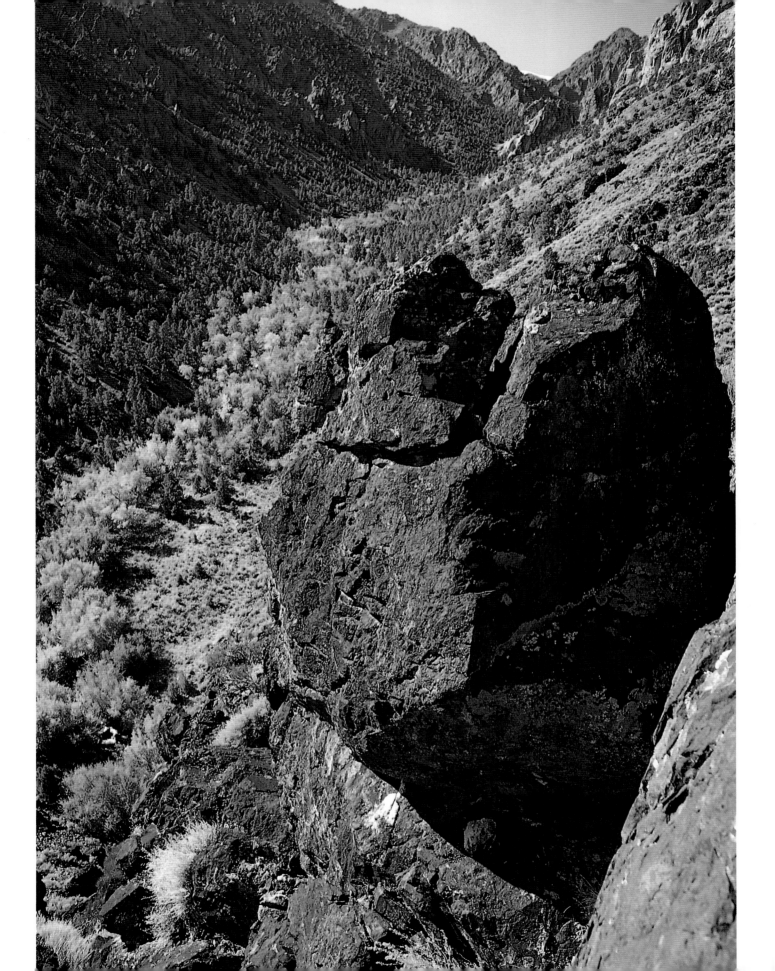

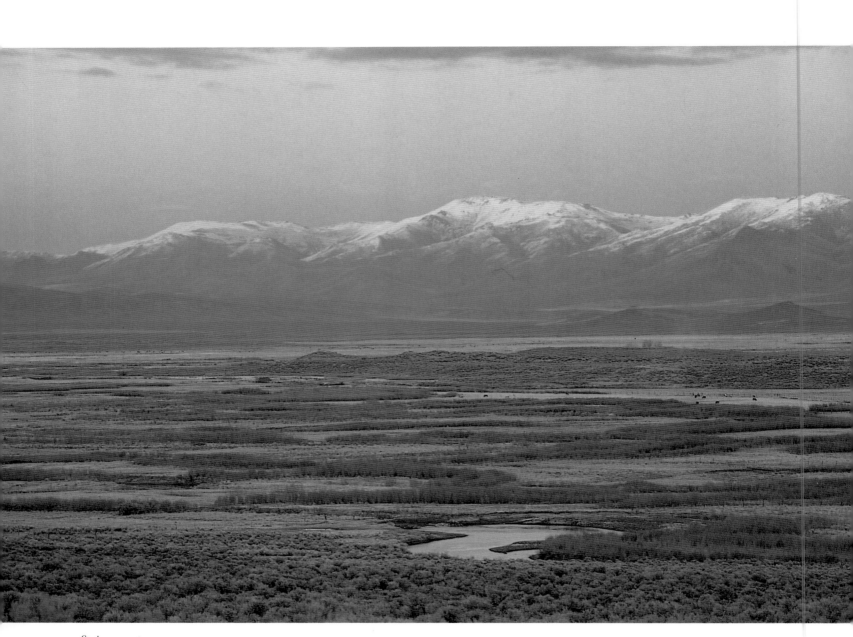

*Spring sunset over
the Osgood Mountains
and Humboldt River bot-
tomlands at Winnemucca.*

would soon dry up in the hot July sun, but just then it was a welcome relief from the tangled branches scratching at my legs.

These two watercourses—the one spring-fed and running strong, the other barely alive with melted snow—seem to me typical. Up from almost any basin and into almost any range in central and northeastern Nevada, in spring if not in summer, such torrents or such trickles can be found. I saw what I expected on the Cottonwood side of Table Mountain, but I was unprepared for what I discovered on the plateau's western slope. Two days later I thought I was in Florida. Barley Creek is primordially lush. Black, peaty soil squishes underfoot, while lime- and emerald-colored reeds close overhead. Hard to follow, a partial path oozes back and forth through brackish vegetation. Startled frogs leap away from a hiker's increasingly wet boots, while pan-size trout loll almost underfoot. I saw only two snakes; I'm sure there were more.

Almost without warning, the upper Barley swamp then turns into the lower Barley desert. Boggy undergrowth and the smell of decay give way to soaring temperatures, scrub saltbush, and cracked clay. Before long, the trail broadens into a dirt track with tire treads cut in the dust, an abandoned supply road for sheepherders a generation ago. Seemingly endless miles of grazed-out flats must be crossed before a footsore hiker arrives back at her truck. Once there, after so many hours of trudging past treeless baked terrain, it's hard to remember the Floridian morning slog. Yet the downward trek stands out in my memory. Just where the trail dropped into Barley's riparian zone, I saw a goshawk nest built atop a twenty-foot snag. One beady-eyed chick stared warily into space, while its mother screeched angrily. If she had only kept quiet, I would never have spotted her offspring.

No trip is complete without relaxing afterward. Geothermal bathtubs bubble throughout Nevada, so I sometimes end a day in hot springs. Near Table Mountain, for example, sits Dianas Punch Bowl, a hundred-foot-high cinder cone that holds a pool of water too hot to touch. While a dip into the Punch Bowl would be fatal, I once lounged comfortably in cooler springs nearby. Today those springs have mostly evaporated, leaving only an inch or two of warm water and a trail of pink scum. Better-known Silver State "spas," such as those found by the north end of Pyramid Lake or the big pools in Soldiers Meadow, are still usable and even overcrowded by Nevada standards. Many more secret ones exist. Nineteenth-century pioneers hated them, for thirsty stock too often crowded too close and either scalded themselves or drowned. Diarists like Andrew Soule, writing in 1854, voiced little aesthetic appreciation for this kind of Nevada water supply. "I thot of Dante's Inferno and the Great Rock of Despair, whose waters cannot cool it off," he wrote of the springs beside the black rock in northern Washoe County's desert of that

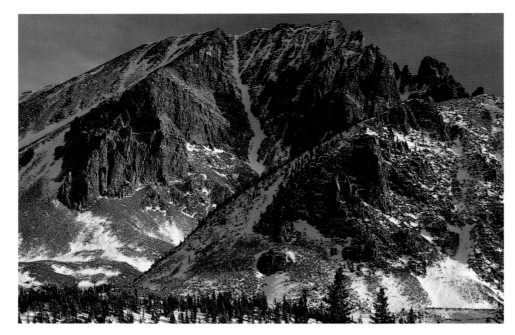

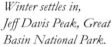

*Winter settles in,
Jeff Davis Peak, Great
Basin National Park.*

name. "I have seen many hot springs but this one can swallow them all and still flow on."
Not only did he and his companions find the water too hot, but also "so brackish with
brimstone, you can't drink it without feeling sick."

The pioneers, late-summer and fall travelers every one, found fire instead of ice in
the Nevada desert. Andrew Soule would have been surprised to see a snowstorm, star-
tled to discover a waterfall of icicles frozen inside icicles. But such wintry phenomena
exist. Standing in sodden knee-deep snow, I leaned against a frosty wall. Three cas-
cades—an almost nonexistent trickle in September, a torrent in May, an immobile ice
flow in March. I heard water dripping inside, but I couldn't see it. When I tipped my head
back, I looked up at more than two hundred feet of solid ice. Less than fifty miles from
this icicle cliff, others were enjoying a warm Las Vegas day.

The fact remains, however: Nevada is a comparatively arid state. The forty-niners
knew that, as they kept to the banks of the meager Humboldt River while wagoning east
to west and as they looked for any sign of potable water in the alkali sinks beyond. We
know it, too, those of us who prowl the desert today. Even though I can think of
hundreds of times and places where water might be found in this dry landscape, I
acknowledge that by most standards Nevada is a parched terrain. In fact, since I have
lived here, we have had relatively little rain at all. A quarter century of off-and-on
drought, broken only by occasional wet episodes like March of 1995, has impacted the
land severely. Around Double O Hot Springs, for example, desiccated brown stalks
remind me that yellow monkey flowers once grew there in profusion. Recently I

searched in the Truckee riverbed for a cottonwood walkingstick, and never got my feet wet. Even as I write these lines, the bitter smell of burning sage floats from a wildfire north of town.

For many people, ongoing aridity connotes monotony. Yet I object to an easy label that tags the Great Basin inaccurately. While it is true that aridity counters conventional notions of what makes a place attractive, it is equally true that dryness generates beauty of its own. Often what I like best comes in response to water. A claret cactus flowering crimson cups after an April rain, or dark anvils clouding and lowering a Toiyabe horizon. Deer prints, large and small, tracking a worn path to an isolated canyon spring, or hexagonal snowflakes, melting on the dry playa of Winnemucca Lake. Because I like to think of the desert as a stage alive with dramatic characters and incidents, I perceive desert water as the engine that drives the life of the land, the energy that keeps things moving.

One Memorial Day I parked the truck on a divide between two of the five Sheep Peaks in northern Washoe County. The noonday sun had been hot, more like summer than late spring, and the afternoon seemed almost sultry. Watching heavy clouds build on both sides of the seven-thousand-foot divide and feeling the air grow more humid still, I knew a thunderstorm would break soon. Lightning began to streak the sky to the south, followed by low rumbles from every direction. I wanted to sit outside and watch the pyrotechnics, but with no trees or bushes in sight, the truck seemed a bit like a lightning rod. I drove off the crest to wait for the storm to blow past. Perhaps fifty yards beyond the divide, I found a semi-level spot and settled there. Soon the rumbles changed to a cacophony of cymbals and drums. Bolts of lightning—too many to count—split across the sky. If I couldn't count bolts, I thought I might count intervals, then realized there were no intervals. A simultaneous flash and what sounded like a sonic pop inside my head meant the storm was almost directly over the truck, a conclusion confirmed by the acrid smell of sulphur.

After the rain began to pummel the ground, it was more difficult to see through the truck windows. I kept peering uphill, though, trying to guess where the lightning had hit. Instead of a brush fire, I saw a herd of phantoms. The lead apparition, a magnificent palomino, stopped in midstride when he discovered the truck blocking the way. Head up, hoofs slipping on the muddy grass, he spun around to chase his harem back into the storm. They all reversed themselves and galloped up over the crest, manes and tails streaming in the hard-driving rain. If I have a picture in my imagination of an episodic interlude punctuating an arid desert landscape, it is a snapshot of that stallion, his mares, the electric moment of their flight, and the pungent smell of ozone and wet sage.

Basins

Sit in one spot for a while—listen, smell, watch the changes. Seeing clouds build and recede, the sun rise, the temperature fluctuate, birds dip and soar, a full moon wane, a season move, makes a landscape more accessible. What may appear lifeless and alien from a distance becomes quite vibrant and familiar when viewed from a desert armchair. Take enough time, and a basin emerges.

As I wrote that sentence, a fat ground squirrel burst out of a hole just four feet to my right. She's been busy all morning; nest building, I think. Scampering away, she returns more slowly with mouthsful of grass and shredded sagebrush. Sometimes she works on a piece of dead sage right in front of me, tearing at frayed wood with both paws and teeth, then filling her jaws. Occasionally she stops to look around, but mostly she

Tumbleweed and seep, Monitor Valley.

43

concentrates on the task at hand. Earlier, from a much greater distance across the meadow, I watched a stripe-eyed badger take morning ablutions. Popping out of an oblong hole, he sniffed, stretched, sniffed, crouched, then sniffed again. After lumbering a few feet and sniffing some more, he pounced. Even with the binoculars, I couldn't see the victim. The badger was holding something, though, as he trundled back to another hole and disappeared. Like the ground squirrel, he too pursued a serious agenda on this first sunny morning in more than a week.

I picked this place accidentally. Trying to outrun a late April snowstorm, I felt the truck tires wallow along a dirt road that was turning to impassable muck. The weather forecast had been most definitive. A fast-moving storm would blow through on Sunday, followed by clearing on Monday. Since I planned to camp somewhere in this basin anyway and since sitting sounded preferable to slithering, I stopped alongside a spring-green meadow edged by valley sagebrush. By dinnertime the winds already had blown the road dry, but I felt no inclination to leave. I liked this lonesome place.

Trusting a Nevada weather forecast was my first mistake; forgetting the word "episode," my second; not driving out of the gumbo when I had a chance, my third. The next day dropped twenty inches of snow just a couple of basins and ranges to the west. The storm set an all-time Austin record—2.22 inches of moisture in twenty-four hours. While this basin certainly didn't receive that much precipitation, I can honestly say that the following week brought few hours without rain or snow or hail. Prisoner of a mud-slick road, I sky-watched and basin-sat.

Basins, those long flat stretches between the Nevada mountain ranges, appear to be the most unforgiving and inhuman part of the high desert landscape. They seem to go on forever. They tend to be dry, though occasional riparian zones break the monotony. Water in the Great Basin, whether snowmelt or spring-fed or the product of seasonal rains, effectively goes nowhere. It drains down to the basins and stops. What little moisture you can find will eventually evaporate and disappear. During my wet April week in central Nevada the water, which never disappeared, drained and evaporated very, very slowly.

Austin and the Toiyabe Range must have trapped a large percentage of Sunday's precipitation. Though snow fell off and on all day, I saw little accumulation along the road. Monday and Tuesday were wetter where I camped; Wednesday, incredibly, wetter still. That day I couldn't find enough dry time to fix a hot meal. An early-morning drizzle turned almost immediately to snow, then snow became hail that skipped through mud channels coursing down the road. By evening the hail had drifted back to sleet, and finally to snow, while the mud flowed soggy white.

Female yellow-headed blackbird in winter-brown marsh grass, Ruby Marshes.

When you're wedged in the back of a pickup truck with little leg- and headroom, protected only by an aluminum camper shell, you find yourself weather-watching. A sun break, a darkening sky, a horizon obscured, the texture of sleet, the size of a snowflake, a cloud shadow—the slightest change leads to endless speculation. You're cognizant of more than the weather, though, because you have time to look closely at the landscape. This particular setting is fortuitous. While the more barren basin stretches distantly north and south, several acres of grassy meadow extend between here and the sagebrush beyond. From the truck window, it reminds me of a manicured golf course. A stream meanders along the meadow's eastern edge. When I went to filter water for cooking, I found the stream fed by fingers of water flowing hot and cold. The combination feels like tepid bathwater.

Actually, the meadow looks better from a distance. Up close it's ragged, with trampled banks, hundreds of cowpies, and a perimeter shrinking from overgrazing. I wonder what this desert oasis looked like a century ago. Though I dislike the damage I see, not everyone disapproves of cattle detritus. I discovered a killdeer's nest snug against a cowpie, its four perfect plover eggs protected by manure on one side and a twist of dry sage on the other. The mother, furious at my presence and full of shrill protectiveness, limped angrily at first. Now she finds me familiar and ignores me when I tiptoe past. Across the valley are more signs of unnatural use. A mine scars the distant range. Brown-red gashes and slabs of bare earth cut the mountain in four different places, slicing up the

steep terrain. When the wind swings out of the east, I imagine a faint mechanical hum from the gargantuan operation.

Along with an occasional hum, a killdeer's plaintive cry, and the dry rattle of my ground squirrel scooting back and forth, I hear both cattle and sheep. They're in the brush, so I can't see them, but their voices are loud and argumentative. All week long they've fussed at the weather, railing at the rain and snow. It must be lambing season. At least twice a day two sheepherders' trucks go back and forth where no other vehicles have ventured. I've also seen the herders on horseback, deep in the sage, checking the ewe sounds. Basins are not silent. Not only the interlopers talk; the native creatures communicate too. Right now I hear other ground squirrels whistling warnings and observations. Five bluebirds cluster for a moment, chitter, then fly south. Other bird calls keep up a perpetual conversation. Two days ago a Cooper's hawk posed on a nearby fencepost long enough for me to find her picture in the bird book. Overhead, I hear wingbeats. A light breeze pushes the brush back and forth, a desert undertone to the choric songs.

After a week of water weather the basin glistens honey-colored clean. Across the flat the setting blurs into a wash of beige and green, but a closer view distinguishes the features. Last year's leftovers—golden shafts of Great Basin wild rye, dried buckwheat, the ever-present sagebrush, clumps of withered grass—are giving way to their younger selves, as fresh spring leaves sprout at their bases. Six days ago I found only a dandelion or two. Today, flowers push toward the sun's warmth. White phlox blanket the ground west of the road, while yellow dandelions cover the meadow in front of me. On my morning walk I saw a serviceberry bush, a honeysuckle, a cluster of Indian paintbrush, a skinny globe mallow waving in the freshening breeze, some penstemon and perhaps a dozen other plants ready to bloom. Even the muddy road has sprouted—water lilies, I guess.

Reclining in my beach chair, watching my squirrel at work and waiting for the road to evaporate, I see a basin alive with the energy of spring. I also see a basin oblivious to human presence. I know if I were unprotected by the truck, without ample water, food, and fuel, I could jeopardize my life in this basin. The weather treats even the sheepherders and their lambs with indifference. The only creatures impervious to the sky changes are the indigenous ones—the ground squirrels, the badgers, the plover, the raptor, the bluebirds, the deer whose hoofprints I track across the road, the harvester ants whose pulsing hills fill gaps between the bushes. I want to conclude that my humanness is inconsequential here, but then I look at the guttered slopes to the east and the shriveled grasses at my feet and I realize the impact we make. Even though the long empty view of silt and sage suggests otherwise, we decidedly have touched this land.

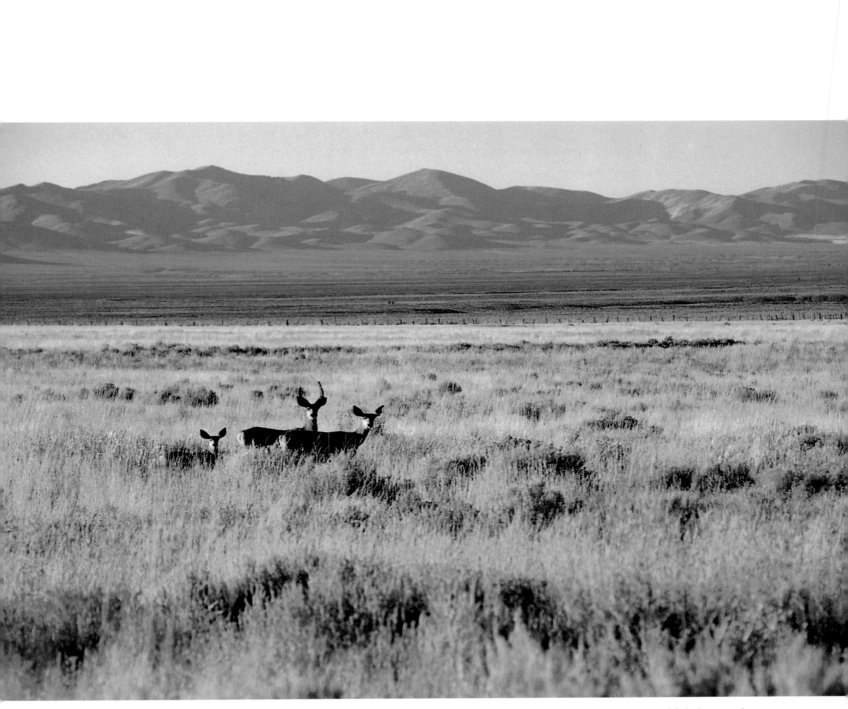

*Mule deer on a desert
stage, Denay Valley.*

An old map marks some sort of lake twenty miles south of here. When I drove past last Saturday, I saw only a couple of ponds. The few remaining wetlands dry quickly into playa. Nevada's basin wetlands, which provide key resting and nesting sites for birds of all shapes and sizes, are diminishing these days. That's partly our fault for using more than our share of the water and partly the result of a natural drying trend. Now some kind of human intervention is necessary if the flyways are to remain hospitable to their avian constituencies. Two of the largest refuges are the Ruby Marshes to the northeast of this basin and the Pahranagat Valley farther to the south. Managed by the United States Fish and Wildlife Service, both offer protected space for mating and migration. By building access roads, dikes and artificial lakes, by controlling water levels, by otherwise manipulating the environment, human stewards accept responsibility for the very existence of these sanctuaries.

Despite a common preservation goal, the Ruby Marshes and Pahranagat are two very different locales. The human ambience of each feels almost disjunctive. You approach the former along a dirt road far from any population center; you find the latter flattened along a major north-south highway. The Ruby Marshes seem a worthwhile destination; Pahranagat, at a glance, a place where eighteen-wheelers and cars inattentively speed past. You access the former by driving along dirt dikes that separate one wetland from the next. You can't camp there in the refuge, though a well-tended campground sits just up the hill. You can't even get too close to the birds in the Ruby Marshes, since much of the waterfowl activity takes place in the reeds at the far ends of the open water. For me at least, the Rubies feel more isolated, more primitive, more appealing.

Several years ago I caught sight of two sandhill cranes waiting for their young to hatch. Not far from the water's edge, safely distant from where people were allowed to walk or drive, the couple nested deep in grasses still brown from winter. One stood at attention, watching first one direction, then another. The other, her or his head barely visible, apparently was incubating the eggs. Now and then they changed positions. While I could get nowhere near this pair to see for sure, I understand sandhill cranes build a mounded nest perhaps five feet in diameter, most often lay two spotted eggs, and wait thirty days for their "colts" to hatch. I also understand the young cranes grow their flight feathers in August, when crane families and crane singles begin gathering for the fall migration. One October, I saw thirty-five or forty of them land together in a field of cut oats, loudly celebrating what they found for supper.

I judge Pahranagat less communal somehow. The southern parts are drying up, so the refuge looks artificial from the outset. Even the cottonwoods signal human intervention. Because some government employee has raised the northern lake level unnaturally

high, the tall trees actually grow in waterbeds. You can camp along the shore of the upper lake—the only one containing much water now—but the sites, at the same time overused and undeveloped, are not particularly attractive. And even though you may sleep a foot or two from the water, not much happens on that side of the lake. The action takes place elsewhere. Traffic on Highway 93 overwhelms the duck calls and bird chatter, though you can escape civilization's guttural noises by walking across one of the dikes. Then the twitters, tweeps, lilts, melodies, quacks, chirps, whines, trills, frog croaks and splashes take precedence over the steady highway drone. Just at dawn, before too many trucks and tourists take to the road, you can clearly hear the bird cacophony from the near side of the lake too—until just one well-placed coyote howl instantly quiets everyone.

Only after I walked out on the middle dike did I find the waterfowl activity I expected. Halfway across, a flotilla of American avocets was sunning itself. I was able to inch within ten or fifteen yards of them, able to see clearly their rusty heads, their stilted legs, their slim upturned bills, their bodies jailbird white with black wings. When I finally got too close they spun into flight, circling the lake in an uneven formation while performing low-level acrobatics and waiting for me to leave. They made several pass-overs while I wandered back to shore, then landed precisely where they had gathered earlier, like elderly men and women salvaging a disrupted routine.

Maybe because it was the slow season between courtship and the hatching of chicks, maybe because the constant highway clamor seemed out of place, I was disappointed by Pahranagat. I thought it overmanaged and underpopulated. I remembered more interesting avian interaction I'd seen at more remote places. Near Duckwater Peak I once camped beside a creek bordered by cottonwoods more attractive and less sterile than Pahranagat's. Near the truck, high up, were kestrels; nearer the water, and lower, downy woodpeckers. For two afternoons I watched parents bringing food to the young housed in their nests. Nonstop, the parents flew off and returned, flew off and returned. I could see little beaks protruding from holes in the tree trunks, could hear tweeps and twerps as the young vied for their parents' favors.

Another year, in a different basin, three juvenile long-eared owls clung tightly to aspen branches and watched me watch them. Out of the nest but not yet ready to fly away, the three patiently waited for the human to leave and their parents to return. Intense yellow eyes, unshaded by the tufts of immature feathers that blew like unkempt eyebrows, followed me as I tiptoed around the grove, trying to get a better view of the young birds. They sat as still as possible, as if I might mistake them for branches. They hardly blinked but, with unmistakable intensity, their bodies quivered just a bit. All over Nevada, such riparian bird energy exists in basins that superficially appear to be empty

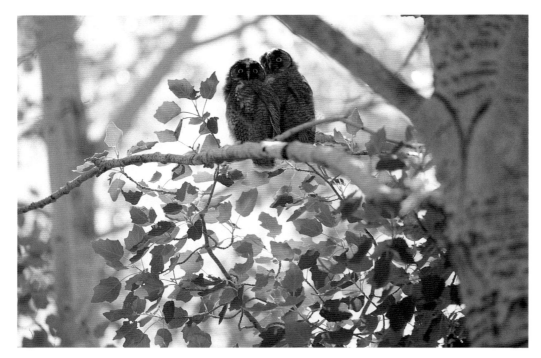

Young long-eared owls in a Hot Creek Valley aspen grove.

and dull. You find species returning to their haunts—a Tonopah friend told me owls have nested continuously in that particular aspen grove for more than twenty years. You also find species acting out their instincts. A bird book, which I consulted after I saw the owls, said long-eared owls habitually stretch themselves to look like tree limbs when they're afraid.

Seeing one set of birds reminds me of others. At Pahranagat I briefly caught sight of a single great blue heron flying laboriously. I recalled an even larger heron I once watched for nearly two hours. It sat preening itself in the snag of a balm of Gilead tree, a poplar planted by early settlers in Dixie Valley. Dixie Valley sits a comfortable distance from Reno, between the Stillwater Mountains and the Clan Alpine Range. Mormons named the valley, then left without a trace when Brigham Young recalled them to Salt Lake City. Theron Turley's grandparents came to Dixie Valley in 1914, the first white settlers after the Mormons abandoned the place. For three generations her family ranched there—running cattle, raising hay, staking mining claims in the hills, making the fertile basin home. Eight or ten other families eventually settled in Dixie Valley too. Now most people are gone and the valley lies empty again. Only some cattle, a geothermal operation, and the United States Navy inhabit its spaces.

During World War II, the Navy began flying training routes over the valley and paid families to relocate elsewhere, with the understanding that those families could return after the war. The Turleys didn't leave. The planes didn't bother them much. With an

abundance of artesian water, Dixie Valley remained a good place to live until, as Theron Turley scoffs, "They showed what they could do to us." After 1985, low-level supersonic flights punctured the valley's air space. Theron tells anecdote after anecdote, narrating the many times she could see the pilots' faces as they flew past. They especially liked to fly under the power lines, she recalls. One day her grandson, lounging on the living room couch, looked out the picture window and saw a plane at eye level. The window bulged inward; the sound was deafening. Though the Navy denies it, Theron remembers another jet buzzing the school bus. I believe her. In Kingston Canyon last July, I watched overhead war games culminate in what felt like a direct attack. One plane flew so low between the canyon walls that I actually saw trees above its wings.

After so many unnerving experiences and four years of negotiation, the Turleys finally sold out. Just before Theron left Dixie Valley I camped in her front yard, alongside an artesian spring and the trademark balm of Gilead where the great blue heron picked at its chest feathers and manicured its six-foot wings. The proud rancher was more than ready to talk about her heritage. Driving around the valley, she told stories about the old days, and I could hear the sadness in her voice. As we picnicked on the steps of a dilapidated family cabin near some abandoned digs to the east, a flock of more than fifty chukars—the most I've ever seen in one place—gave the only sign of life. On another hillside we found petroglyphs. Someone once told Theron that a metal punch made these pitted markings, that they are of Spanish rather than Paiute or Shoshone origin. No one knows the truth. Back down along the gravel bars in the valley, Theron showed me where, when she was a girl, she found petrified remains of prehistoric animals lodged in the dirt. She pointed out artesian wells, home to still another relic. The turley tui chub—named for the family—swims only in Dixie Valley. How the tiny fish, one of thirty-two related species found in Nevada, survives is a mystery. If you move these fish away they die, Theron poignantly observed.

Lounging here in my mud-bound basin, I compare my lazy human presence in the Nevada landscape with a Turley lifetime or a sheepherder lifestyle or a mining or military enterprise. A jet flies overhead, one herder just slogged past, and I think I hear the gold ore hum. We all affect the environment in one way or another, impressing upon the land a human imprint. We claim it—for mineral extraction, for national defense, for livestock, for wildlife, for the natural ambience, for whatever pleases us as human beings. Anthropocentrically, we try to make the landscape ours. But it is difficult to exert authority over a basin. Corners of one may be hospitable, but what if it were arid, sterile, mineral-free, good for nothing? What if it were playa? And hot? South of here, where this basin eviscerates into playa, you finally see only mud, clay, silt, alkali, and a little sand. Totally

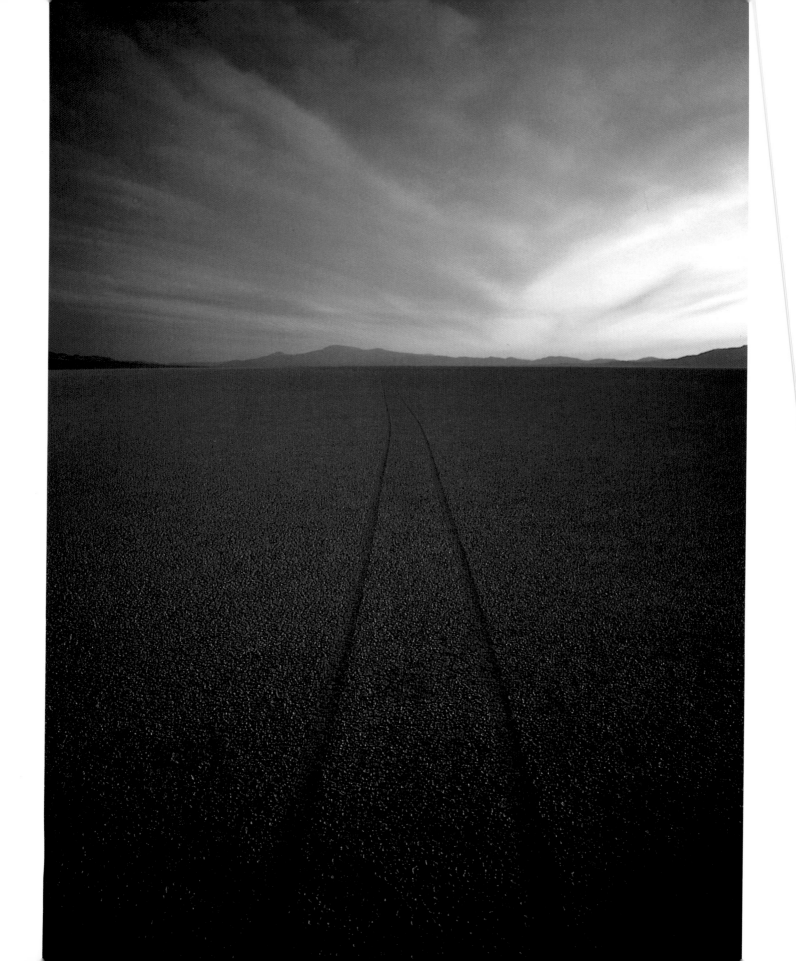

dry most of the time, devoid of vegetation and most animal life, virtually colorless, desert sinks are abstractly unappealing. Summertime temperatures average well over a hundred degrees; there is no shade. Standing in the middle of a playa puts one's anthropocentric ego in perspective.

The Black Rock Desert lies a hundred miles north of Reno. More than four hundred square miles—so vast you can actually see the curvature of the earth—the Black Rock is a place where the human dimension gets lost. I like to park in the middle of it, and walk away from the truck. If I go far enough, the truck recedes to the size of a pinpoint. I have to keep an eye on some landmark at the edge of the playa in order to find my way back. Eventually I lose sight of my vehicle, my human companions, and any sense of perspective. Then I run, maybe in circles, sometimes with my eyes closed. When I open them, I am lost.

As startling as what you see is what you think you see. Mountain ranges float in the desert heat, or so it seems. Light and heat trick the imagination, blend into lakes that don't exist and mountains that move. From the center of the Black Rock I've watched the Jackson Range shiver in a July sun, tried to pick out King Lear Peak and lost its nine-thousand-foot summit in a blur of apparent water and sand. Shapes shift on the horizon, while blue lagoons drift in and out of the picture. I look down at my feet and see desert parchment, a cracked checkerboard of silt and dried mud; in the distance, an oasis beckons. I stumble toward the mirage, but sanctuary vanishes as I move.

Sound shimmers on the playa, too, or perhaps I should say that silence shimmers there. It is possible to hear nothing at all in the Black Rock. Utter silence is difficult to describe. You strain to hear a sound, any sound, or you relax and let nothingness echo in your ears.

> And this is why I sojourn here,
> Alone and palely loitering;
> Though the sedge is withered from the Lake,
> And no birds sing.

John Keats's words hold true geographically and biologically as well as emotionally and spiritually. Out on the playa the sedge truly is withered from what once was a lake, and, even at dawn, no birds sing.

Poetic self-indulgence or such frivolities as walking away from the safety of a vehicle, relishing the interplay of mountain and mirage, pretending the void of utter silence, are possible in the quasi security of the late twentieth century. Pioneer travelers surely felt less sanguine. They filled their diaries with fearful observations and dire predictions

Tracks on the Black Rock Desert playa.

about what one woman called "a weird and dreary scene." Even in the 1970s the Black Rock Desert felt more lonely and desolate than it seems today. Fewer people visited it, not only because fewer people lived in Reno but because still fewer owned appropriate vehicles. Driving north of Gerlach was an adventure. After a wet winter, a playa like the Black Rock can be a sinkhole for the unwary driver. Twenty years ago I slowly followed a two-lane rut out to the hot springs at the base of the monolith that gives the desert its name. If I had veered to either side of that narrow track, the truck would have sunk to its hubcaps. In the drier 1990s, a visitor to the Black Rock is more likely to cruise at sixty miles per hour or even faster along the well-worn playa roads now fanning out from Gerlach. One must take care, though. Calling a tow truck from the middle of a four-hundred-square-mile expanse is not a simple task.

I had just finished lunch and was comfortably settled in the middle of that vast expanse, reading a murder mystery, when I heard footsteps on the desert floor. Like a scene from a Zane Grey novel, a lone man lurched toward us. "Water," he moaned. No mirage—though for a moment I thought I was dreaming—he reached out a hand. I drove him back to the pickup he and a friend had high-centered in the dunes, perhaps two miles from my lunch spot and more than forty miles from the nearest phone. The men had been stuck since the evening before. My four-wheel-drive truck easily pulled theirs out of the sand, but a punctured gas tank meant they were unable to get back to Gerlach by themselves. An amusing anecdote of a man with a hangover bumbling across the playa? I'm not sure what he would have done if, instead of deciding to read for a while after lunch, I had unwittingly driven off in the other direction.

A hot summer afternoon in a dry basin brings its own dangers—thirst, dehydration, disorientation, sunstroke, maybe worse. Last August, I watched heat lightning spark above the desert pavement. Patterns of light spiderwebbed from south to north like a checkerboard reflection of the playa below. No rain, no accompanying thunder, nothing but a spectacular two-hour light show in the desert darkness. Once—and only once—I ventured out in the Black Rock when the wind was blowing hard. With such an un-broken expanse in which to pick up speed, the wind can accelerate with hurricane force. If you're driving fast, sand and silt billow faster; if you're sitting still, grit camouflages everything. Without a track to follow, without a compass, without anything anywhere except dust blowing, you can hardly tell up from down. I've never been on the playa in a blizzard; I imagine it's the same.

The immense otherness of a playa invites a surrealistic response. When I run away from my truck with my eyes closed, I create for myself a kind of surrealistic world. To resolve its contradictory conditions, I aim toward a new-desert super-reality—represent-

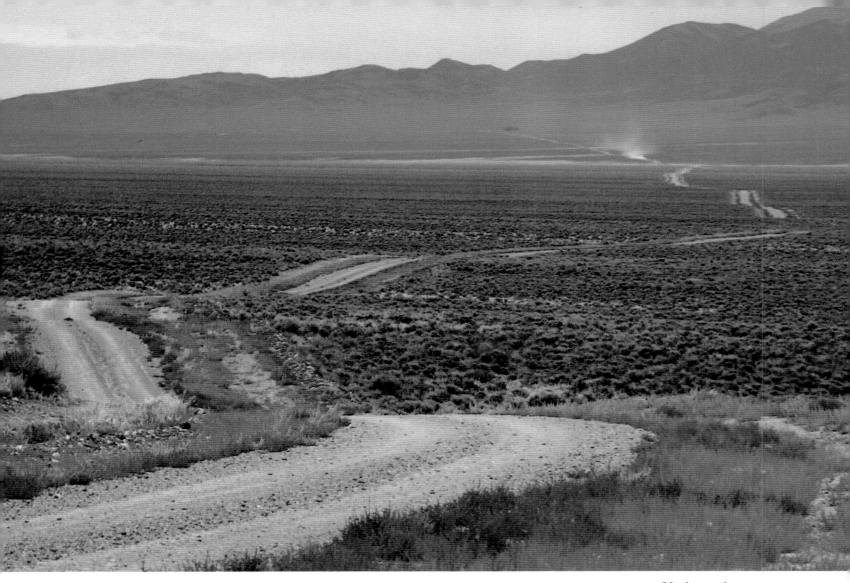

*Heading south
through the lonesome
basin of Monitor Valley.*

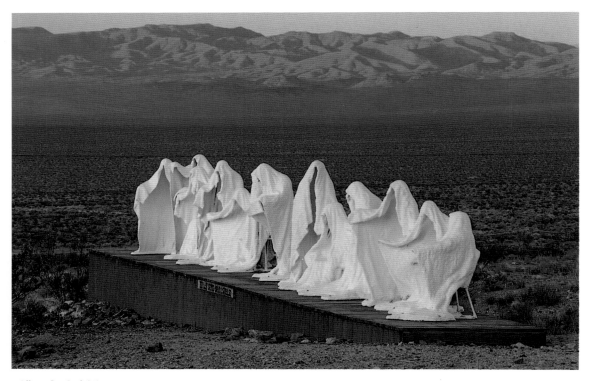

Albert Szukalski's "Last Supper" on the rim of the Amargosa Desert, Rhyolite.

ing irrationality as tangibly as possible and mocking the aura of the playa floor, balancing my own humanity in that unearthly earthly world out of space and time. Nothing I personally do in the desert, however, is as surreal as the Labor Day festival of the Burning Man.

Every year a group of Californians builds a forty-foot-tall, 1,500-pound figure, trucks him in pieces to the middle of the Black Rock, raises him upright, spends a weekend cavorting around him in celebration, then burns the man down. Some call the event "the bonfire of the insanities." It's certainly a party on the playa, with more than two hundred people joining in the festive ritual each year. Volunteers hoist the man into place. Like students at a college tug-of-war, everyone grabs a piece of rope and pulls. The skeletal figure wobbles, sways, stiffens, looks as if he'll never stand on his own. Finally erect, with his extremities held fast by guy wires, the man lights up. Amethyst-blue neon tubes outline his thighs, his arms, his rib cage, and his head, so he is visible from miles away. Drums throb an age-old rhythm while participants coil around the base of this modern-day icon, swaying their existential allegiance. The next night, in a burst of flame that seems to ignite every part of him simultaneously, the man is set ablaze. The dancers gambol 'til dawn.

Many Nevadans think of the Burning Man as post-hippie foolishness, pyrotechnic masturbation, or performance art out of control, but I disagree. I think this engineered

absurdity, this late-summer-night's dream legitimately exposes human triviality. So does Guru Road, a series of eccentric memorials quietly overlooking the Black Rock playa from west to east. Made of desert materials, beer cans, and paint, the stations of "The Wonder Road, A Story with No Beginning and No End, Destination Unknown, Maybe Something for You, Your Life May Never Be the Same" are another man's notion of desert play. Six hundred miles to the south, a group of Belgian artists have done something just as quirky and surreal. Half a dozen sculptures guard the road into Rhyolite. *Icara*, a larger-than-life female Icarus by Andre Peeters, is an angel flying to the sun. Peeters says he created her as "a response to the vastness of the desert landscape." Hugo Heyrman's even taller female figure is *Lady Desert*, a blockish pink-and-yellow nude that he calls "the Venus of Nevada." Most complex of the sculptures is Albert Szukalski's *The Last Supper*—ghost images made by wrapping live models in protective plastic, then draping them with cloth soaked in wet plaster. The models slipped out after the plaster had set, leaving rigid shrouds behind. When I suddenly came upon these shadowy draped apparitions on the road to a ghost town, I again experienced that desert dislocation between an indifferent landscape and a very tentative human presence, between reality and dreams. These sculptures, I understood, interposed one more way to mark the land.

Since explorers first laid eyes on Nevada basins, humans have sought ways to connect. The black rock itself—the promontory that cuts into the playa, not the desert that bears its name—invites the desert traveler to make contact with the one tangible thing that breaks into the horizon. Because the black rock is so isolated and so prominent, I always feel the urge to stand on top. The easiest route goes up the backside. A frenetic scramble over talus and broken rock—two steps forward, one back—an easy pull up a short steep place, and I'm there. To both west and east lies a flat, colorless, almost limitless, stretch of playa; straight down, the bubbling sulphurous vapors of the hot springs that so unnerved the pioneers. I feel lonesome up there.

I don't feel lonesome today because my prepossessing basin vista is green instead of brown, because the weather is temperate rather than frigid or scorching, because I sit beside a real oasis rather than a mirage. I have no need to climb a hill in order to connect. In fact, I feel an honest affinity for this place. Unlike the playa, where neither plants nor animals seem to live, here I'm surrounded by reminders of a tangible world. My squirrel, a spring-fed stream, the killdeer, dozens of sheep, a yellow patch of nameless flowers, sagebrush, a pickup truck that offers security even when its four-wheel drive isn't working. Some might say that choosing to spend a week weathering a spring storm—and then smiling about it—is the height of irrationality, an act of foolish mockery, my own sur-

realistic gesture toward the basins of Nevada. I think not. The ultimate surreal statement for this location, I'm convinced, is the gold mine across the way. Elsewhere, it's a jet fighter flying at eye level with a rancher's kitchen window.

Remember Shelley's monument to Ozymandias, a statue erected in the desert whose countenance was built to last forever? Like the Burning Man, the giant figure fell.

> Nothing beside remains. Round the decay
> Of that colossal wreck, boundless and bare
> The lone and level sands stretch far away.

Like the Black Rock playa; like this unnamed valley; like all Nevada basins, eventually, long after humans make their human gestures.

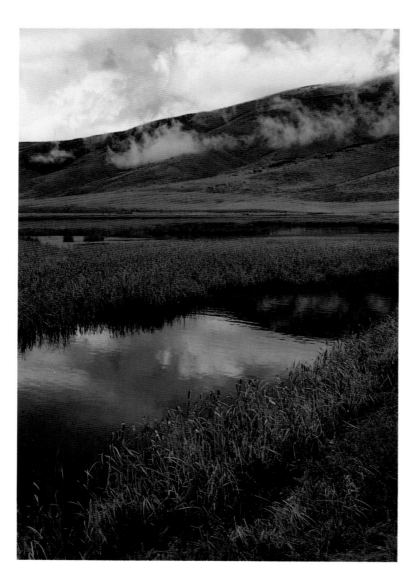

Wetlands preserved for waterfowl, Ruby Marshes.

Ranges

Although not all of Nevada lies within the Great Basin, basin and range terrain defines all of Nevada. One line of demarcation runs erratically across the state—somewhere south of Tonopah and north of Beatty, somewhere south of Caliente and north of Alamo, wherever the Joshua trees first or last appear. North of that line, the Great Basin collects and hoards its waters. Southeast of there, the lower and hotter Mojave Desert drains to the Colorado River. Another imaginary line slices off the upper right-hand corner of Great Basin Nevada. Its water runs north to Idaho, the Snake River, and ultimately the Columbia. While the characters of the three drainage patterns differ, the landscapes are remarkably similar. Angular mountains line the horizons; flat valleys fill the spaces in between. Nineteenth-century cartographer and geologist Clarence E. Dutton aptly described the high profiles as an "army of caterpillars crawling toward Mexico."

That army numbers more than three hundred strong. Each mountain range, approximately thirty miles from its neighbor to either side and somewhere between fifty and a hundred miles long, roughly parallels the next. One of the biggest differences between Silver State mountains and alpine regions in other western states is the narrowness of a Nevada range. A single zigzag ridgeline, usually with a sharp escarpment to the east and a gentler defile to the west, may boast only a noticeable peak or two. Standing on top and turning either east or west, you look down on basins instead of more mountains—down on grabens instead of more horsts, a geologist might say. Each range, or horst, even though it may contain peaks 10,000 or 12,000 feet high, essentially is graben-circumscribed. Because Nevada mountains have this caterpillar configuration, it is impossible to design the sort of high-elevation wilderness trip you might plan for a Montana or Colorado outing, though I've backpacked to Nevada sites as rugged and remote.

By conventional standards the Ruby Crest Trail is the most scenic and, until the creation of Great Basin National Park, the best known. Partly because high lakes remind people of the Sierra and partly because of excellent fishing, the Rubies draw many visitors. To penetrate other ranges, you may have to steer a four-wheel-drive vehicle along a perilously unmaintained track or else trudge wearily up a steep, shrubby slope. By comparison, the Rubies are readily accessible. A paved road winds up through Lamoille Canyon to the 8,800-foot level, where the forty-three-mile Ruby Crest Trail begins.

The first three miles switchback past a series of picturesque meadows and mountain lakes set against glaciated rock. Because the Rubies are high, with several peaks above 11,000 feet, and because they are situated exactly where storm patterns intersect, the range captures more than its share of moisture. As a result, in July and early August flowers grow profusely. I lost my favorite hat in the Lamoille meadows, leaving it behind when I knelt to examine the orange globe mallow it matched. I find the Rubies just as visually distracting in the fall, when aspen colonies simultaneously shade into gold. Even disguised by several feet of snow, this range is colorful.

Once over Liberty Pass—a rather effortless thousand-foot summer climb through scenery that looks transplanted from Donner Summit—the trail descends quickly to Liberty Lake, a deep blue rockbound cirque. Many hikers stop there; few scramble to the high ridges east of the lake. But I needed to walk off a fresh trout brunch one day, so I worked my way up the stony slide and then wandered along the edge toward Lake Peak. Though the drop-off from the ridgeline to Ruby Valley is dizzying, the ridge itself is relatively flat on top. Avoiding occasional leftover snow patches and circling scrawny pine, I strolled across the rocks at a very lazy pace. Two marsh hawks were livelier than I. They cavorted overhead—catching an updraft, floating down, diving at each other and at

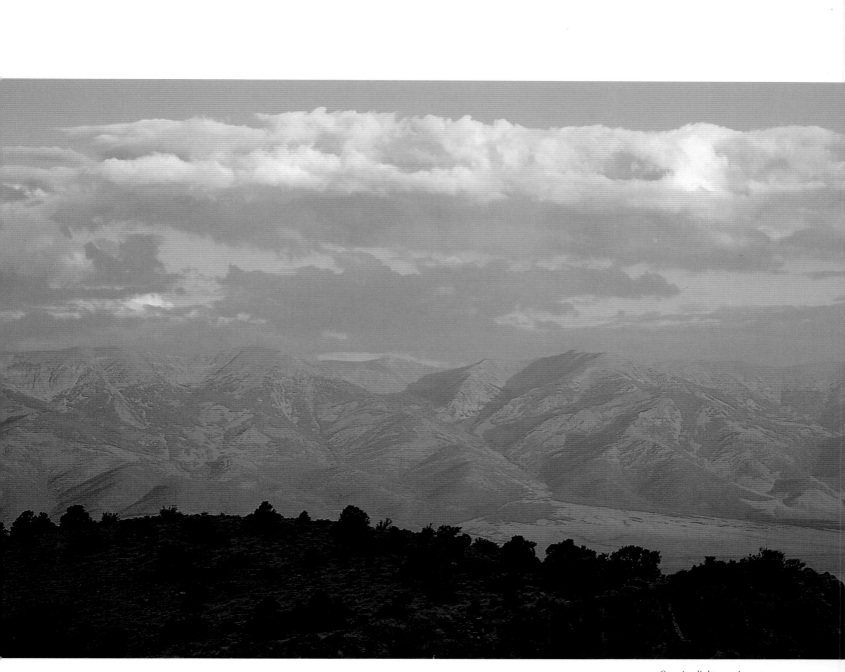

*Sunrise light moving up
the Schell Creek Range.*

At Favre Lake, the Ruby Crest Trail passes through meadows below Lake Peak.

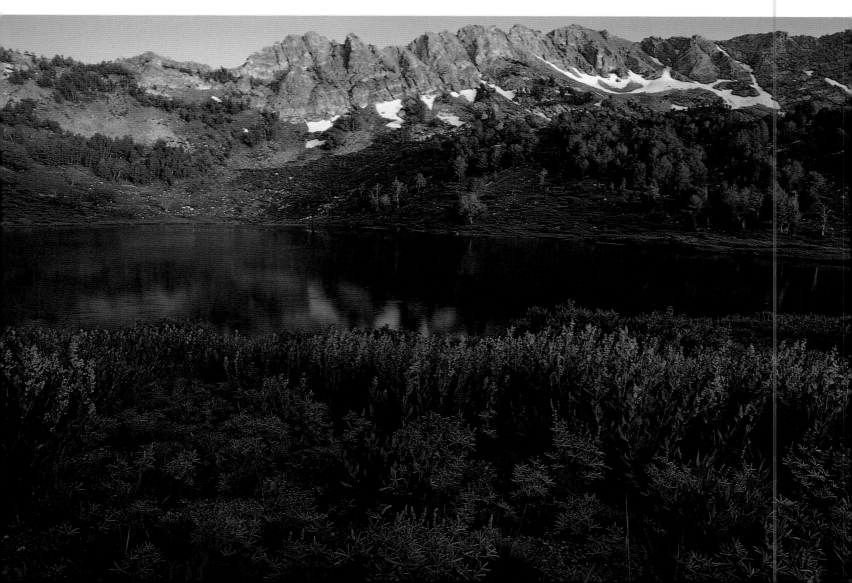

me, then spiraling up again and flapping their wings in play. I mostly watched the two while I walked, but occasionally I veered to the left to look down at the green irrigated valley below.

I thought I was daydreaming when, not six feet from where I paused, I found a mountain goat asleep on a snowbank tucked beneath the edge of the escarpment. Full-grown, the mountain goat dozed with her head resting on her front hooves, her eyes closed, her breathing gentle and measured. She had no idea I was there. Once, when I was a teenager, a cougar crossed ten feet in front of my path. That day in the Rubies I felt the same breathless wonder, the same quick heartbeat, the same disbelief. The goat was big—bigger in retrospect than in reality, I confess. Her dirty off-white coat was mottled and shaggy, a rather unglamorous end-of-summer outfit. Then I noticed her horns. "Hello," I said. "Do you charge?" The words were out of my mouth before I thought about them.

Startled, she lifted her head and looked straight at me while she thought about my question. As she rose slowly to her feet, I could see her deciding. No. Movement at the far end of the snowbank distracted us both. Peering around a rock overhang, a much smaller and younger mountain goat watched our encounter with fascination. When the chunky kid started to come toward us, his mother quickly turned from me and herded him away. Within a minute they were gone, though he took one last backward look before they crossed a corner of the cliffline below.

I don't carry a camera when I hike, so I have no visual record of my two mountain goats. The next day, though, the angler who had stayed back at camp urged me up the hill again. Like cats, she insisted, they'll return to the same sunning spot every afternoon. I scoffed at such a silly notion, but agreed to show her how close I had been to the goats. We got there—and found only the marsh hawks at play. She wanted a picture, so, very gingerly, I edged onto the snowbank and posed. Just as she snapped the last frame, the inquisitive kid stepped around the rock overhang again. This time his mother stood alongside him, until her better judgment finally overpowered her curiosity and she nudged him toward a steep rocky chute where no human could follow. I'll always wonder if they returned a third day to see whether we had intruded one more time.

The Nevada Division of Wildlife released six mountain goats in Seitz Canyon in 1964, six more in Lamoille Canyon in 1967. Since then, a small herd has flourished—an August 1992 aerial survey counted 130 goats along the Rubies' highest cliffs. Just as these animals are an anomaly in northern Nevada, so the scenic Rubies themselves are somewhat unusual. Glacial cirques are rare in ranges more commonly lifted and faulted and limestone-designed. South from Dollar and Lamoille and Liberty and Favre and Castle

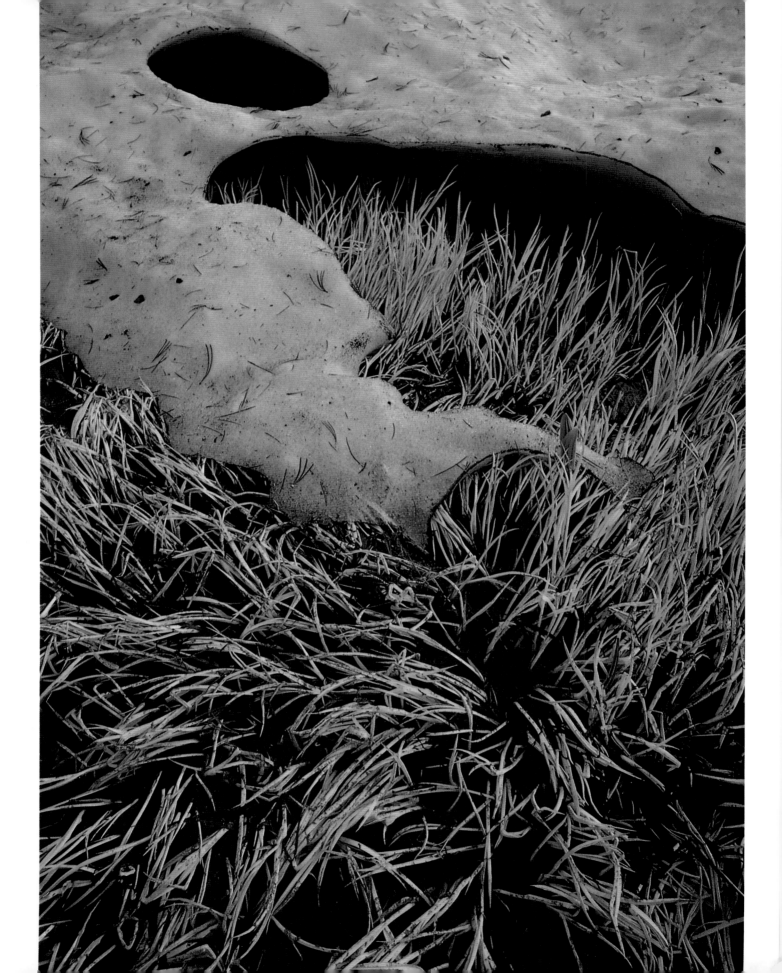

and North Furlong Lakes, however, the landscape changes back to more typical Nevada alpine scenery. The crest trail seesaws over tundra, several alternating miles of snowbanks and flowers. Following the faint track on foot is relatively easy, but mapping the way turns out to be frustrating. The trail winds back and forth from one map quadrangle to another, between one fifteen-minute series and two seven-and-a-half-minute series. To locate myself took too much time and effort, so I put the maps away and enjoyed the scenery.

No, I didn't get lost. But I did walk nineteen and a half miles that day before finding a place to camp. There's nowhere to stop comfortably between the Wines Peak tundra and the Overton Lake cirque. First, plenty of flat spots without water. Then, hung with waterfalls, a cliffside too steep to pitch a tent. Waiting for the perfect campsite and refusing to count contour lines on the maps, two of us slogged onward. And onward. And onward. The next day the angler was so tired she released what she caught—too much trouble to clean, she announced. I don't believe I walked more than a hundred yards.

After Overton Lake the trail climbs a short, steep pass, then drops down to cattle country. Where the canyons beneath Wines Peak had been dotted with sheep, the canyons south of there were filled with cows. They even surrounded the springs, forcing us to build a barricade to keep them out of our last campsite. Farther south the landscape dries out completely, until finally there's no water—and no cattle—at all. The Ruby Crest Trail ends at Harrison Pass, where we met an Elko friend who ferried us back to Lamoille Canyon. Someday I would like to see the bristlecone pines that I'm told grow beyond Harrison Pass on the slopes of Pearl Peak. To hike farther south, however, I'd be forced to haul my own water. I'd rather carry a lighter pack to a wetter destination, though that's not always a Nevada option.

Often I pick out a range and spend a week camping around its edges, hiking up a different drainage each day, climbing to the high points, comparing what lies on a western slope with what drops off to the east. When I combine that kind of trip with some backpacking, I get to see a range from nearly every angle. Last summer I spent ten days in the Jarbidge Wilderness north of Elko and south of the Idaho state line. First established with the passage of the 1964 Wilderness Act and then expanded in 1989, the current protected management area encompasses 113,200 acres, with eight peaks higher than 10,000 feet to explore.

Some visitors think just getting to Jarbidge is a challenge. The most direct route from the south, which blizzards close in winter and where drifts may linger until July, skirts the deep drainages of Copper and Coon Creeks. While inexperienced drivers might not like this twisting, narrow dirt road, the vistas are incredible. A year-round route, less precipitous and more protected from harsh weather, circles into town from

Sedges and melting snow high on Mt. Rose, Reno's backyard mountain.

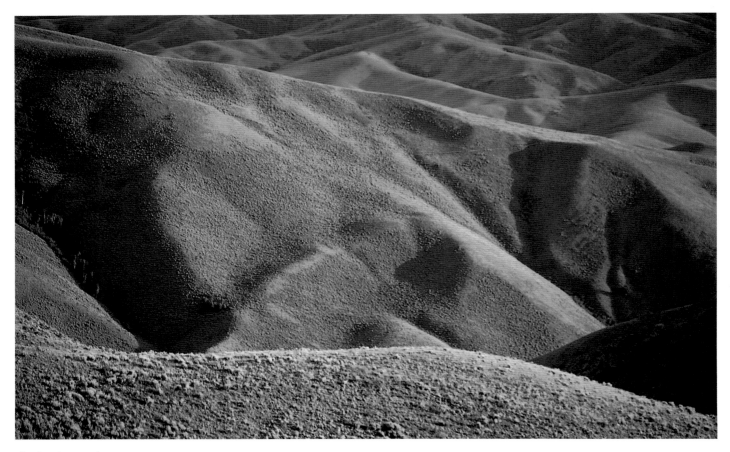

Sagebrush-covered hills above the Bruneau River in the Jarbidge backcountry.

the north. Jarbidge looks like a Hollywood set. Site of the last stagecoach robbery in the United States, home today to perhaps a hundred permanent residents, and boasting two turn-of-the-century saloons plus a trading post and a gas station, Jarbidge calls itself "a living ghost town." Indeed it is. Legends agree it borrowed its name from a Shoshone phrase, but translations differ. Although I appreciate the sentiments of those who say Jarbidge simply means "beautiful place," I prefer the more colorful options—"devil place," "a weird beastly creature" or "monster that lurks in the canyon."

To judge the most appropriate phrase, I backpacked up Snowslide Gulch to Jarbidge Lake and then crossed the high divide. Snow still camouflaged the trails, so I slid into one basin and slipped into another. High points like Marys River Peak, with an elevation of 10,585 feet normally easy to climb, were more daunting with snow-cover slick from freezing rain. Because I'm too cowardly to chip an ice-axe-less way up any potential avalanche chute, I missed Cougar and Matterhorn and Square Top and Jumbo Peak too. Instead, I worked my way over to Emerald Lake, still frozen solid at 10,166 feet, its waters buried beneath a crust of ice. No fishing there for a while. After lunch I contoured back to the pass, where I sank to my knees in sun-softened drifts. Not devil

country exactly, but difficult when winter hangs on. Unlike the well-traveled Sierra or even the Rubies, in four days I saw only one other person. Perhaps the single most attractive feature of so many Nevada ranges is, quite simply, no people. No devils, either. Just an occasional mule deer usurping the trail.

Back in Jarbidge I checked out the local businesses, then gassed up the truck and drove north. I realize now how much I've changed since moving to Nevada. Instead of staying a couple more nights in the mountains or in Jarbidge Canyon—two picturesque locations, one of graceful, pointed firs and one of sculpted rock formations—I turned up Buck Creek and camped on a plateau where I could see horizons in four directions. I felt free somehow, liberated instead of enclosed. Three days later, I joined a ranger district tour that would take me farther north and then trace the eastern edge of the range. The U.S. Forest Service invited two dozen people who ordinarily view patterns of land use in diametrically different ways. Firsthand, I heard the synapses of cattlemen, sheepherders, Bureau of Land Management professionals, forest rangers, biologists, hunters, hikers, and conservationists talking at each other.

We stood on Forest Service land and looked toward BLM water, stood on the O'Neill Overlook and looked toward Pole Creek Canyon. Or did we stand on the Pole Creek Administrative Site and look toward the O'Neill drainage? Not only the rules and regulations, but the very names of the watersheds differ from bureaucracy to bureaucracy. The conversation focused on the confusion and frustration felt by everyone, especially the local ranchers. All agreed, however, that undulating grasslands and deep coulees make prime scenery. A few hours later, we eyed some of the best hunting country in northeastern Nevada. I remember camping in Jarbidge on the eve of bow-and-arrow season, when hundreds of khaki-concealed men waited for an August dawn. Now a brooding sunset, spreading behind Gods Pocket Peak, tinted the sky red. I listened to more uneasy conversation, but I don't think I really understood the discontent and dissatisfaction until afterward, when I drove into Chalk Basin.

Everyone on the tour had urged me to visit this scenic Marys River drainage, for they remembered a lushly vegetated riparian zone. I found the opposite—miles of overgrazed hills without foliage, weary cattle scraping their hooves, dust devils and black flies. The tour, tactfully designed to take us through well-managed rangeland, hadn't steered us here. Stargazing that night, I considered what I'd seen and what I'd been told. Approximately 8,000 sheep and 10,000 cattle, more or less, are turned loose in the Jarbidge each summer. By manipulating the system, by grazing ewes and five-month-old lambs (which don't count) instead of ewes and six-month-old lambs (which do), a sheepman can effectively (and legally) double his allotment. "Do you punish a permittee when

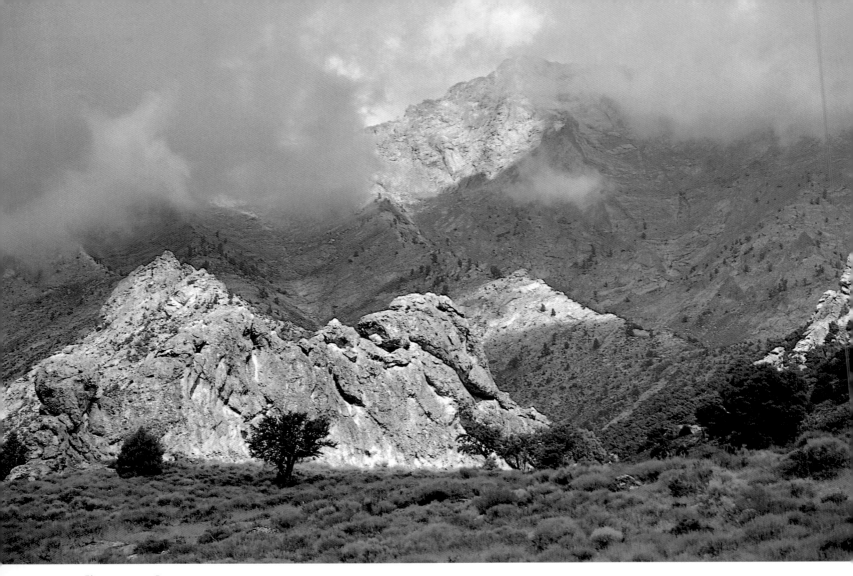

*Clearing storm, Lutts
Creek, Ruby Mountains.*

things go wrong?" one environmentalist asked. "No," replied a BLM manager. No fines. No allotment cutbacks. "If we tried, the ranchers would barbecue us," the government man defended himself. "You've gotta pick your battles."

I'd rather not think of Nevada ranges as war zones. If they're battlefields at all, I judge them places where an individual challenges the elements, and perhaps herself. Peaks, where utilitarian disagreements can't flourish, preclude an ongoing human presence—though many of us like to scale the heights. Mount Charleston, high point of the Spring Mountains west of Las Vegas, for example, or Mount Rose outside of Reno; King Lear Peak to the north; Boundary Peak on the state's western edge; Wheeler Peak and Mount Moriah in the Snake Range; Mount Jefferson; Arc Dome. No one can earn a living on such rugged rockbound pinnacles, but a successful hiker can be lord of all she surveys. I always feel an incredible possessiveness when I stand atop a summit. As soon as I moved to Reno, I climbed 10,778-foot Mount Rose. I suspect if I were newly transplanted to Las Vegas I would immediately ascend 11,918-foot Mount Charleston for the same reason. It's the highest spot. Over the years I've scaled Mount Rose in three of four seasons—in April after a winter drought, when a sharp, cold wind belied the lack of snow; in hot August, when I hoped heavy anvil clouds would stay south of Lake Tahoe until I got off the top; in October during Indian summer, when yellow-gold aspen line Galena Creek and dried grasses signal winter just ahead.

I last climbed to Rose's summit when July flowers were at their finest. Where the dusty road turns toward the meadow, lemon-colored primrose, like crumpled yellow tissue paper, pointed the right direction. Where the trail winds out of the meadow, I walked through a rock garden in sagebrush. Knee-high purple lupine gave way to boot-high white lupine. I saw sego lilies, elephanthead, umbrels, penstemon, thistles, columbine, and four different varieties of buckwheat. Deep colors; deep smells. Sitting on top an hour later, I looked down on the meadow with its swales of green to Lake Tahoe beyond, a teacup holding liquid blue. Conventionally beautiful scenery, to be sure. A lavender mist had tinted my early-morning view while I'd been hiking, but now Reno and Sparks appeared in contrast dryly brown. Smog tainted the horizon in every direction. When I climbed Mount Rose in 1970, I could see Mount Shasta clearly; by 1994, even Lassen's silhouette was blurred. Still, I relished the view and, like a Himalayan mountaineer, the psychological high of accomplishment.

Farther from population centers the skies are brighter, the peaks just as enticing. I have two favorites—Jefferson and Arc Dome. The former, a heavy, stolid mountain with three distinct square-browed summits, dominates the Toquima Range. Across Big Smoky Valley the latter, a more graceful rounded cone, overlooks the Toiyabes. From

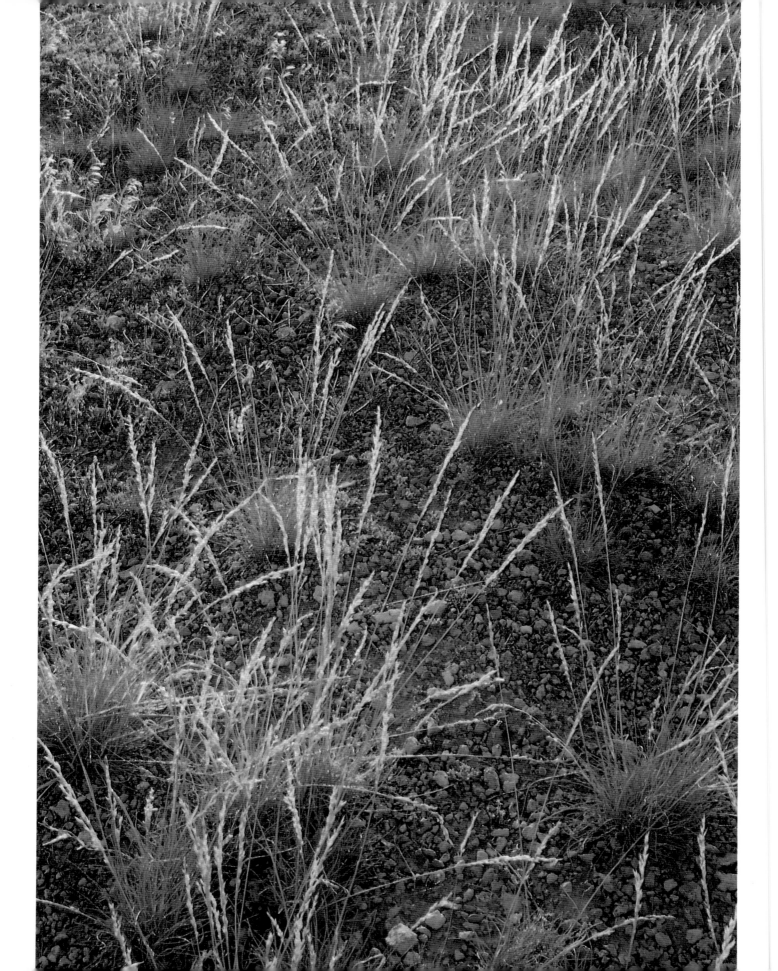

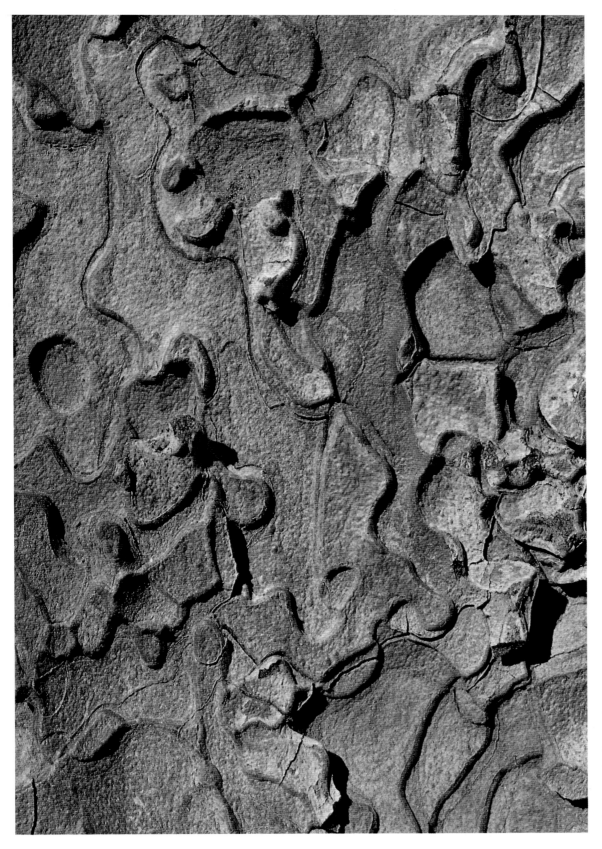

opposite:
Grass, Ferguson
Mountain, Goshute
Mountains.

Ponderosa pine bark,
Mount Charleston,
Spring Mountains.

the air, especially buried under impermeable winter snow, both Jefferson and Arc Dome look menacing and dauntingly rugged. From the ground, however, neither is particularly forbidding and either can be climbed without technical support.

I visualized the route up Jefferson's 11,941-foot south summit one afternoon when blue butterflies surrounded me. One sat on my notebook, one on my pen, another on my knee, one more on my right foot. A nebulous hummingbird whirred to and fro, while the sun disappeared behind a drift of clouds. I expected a storm that night, but none materialized. Instead, I woke to see clear skies and a clear trail up the mountain. I'm always fascinated by the way alpine scenery unfolds as I go higher. At the mouth of Jefferson Canyon, the Round Mountain mine seemed to spill farther onto the valley floor every time I looked down at it. Horsethief Canyon seemed to deepen, a green watercourse, a green seep, a green thread. Beyond, I kept eyeing the Toiyabe mountains and Arc Dome, snowless in midsummer; in the other direction, Table Mountain, then Duckwater and Currant growing taller behind the table's flat crest. For a mile or so I couldn't see the top of Jefferson, could get my bearings only by looking at the ranges left and right. When my destination confronted me again, it looked depressingly distant, impossibly far away. It wasn't, though. After contouring across a steep talus slope, climbing to a saddle, and picking my way up a grassy tundra sward, I stood on the treeless south summit. To the north, I measured Jefferson's other two high points—two more flat summits above 11,000 feet, two giant steps perhaps, but with unfortunate dips between.

I appreciate John Muir's view of Mount Jefferson. "This is a very marked and imposing mountain," he wrote in 1878, "attracting the eye from a great distance. It presents a smooth and gently curved outline against the sky, as observed from the plains, and is whitened with patches of enduring snow." His *Steep Trails* words remain true today, though I personally would characterize Jefferson as even more massive, with a rougher outline and less gentle curves. I saw the enduring snow patches, however, despite a valley temperature that touched a hundred degrees. Muir's description of Arc Dome is less successful, I think. He dismisses two tiny lakes, barely mentions a small residual ice patch that since has disappeared, and solemnly notes glacial sculpting of the adjacent ridges. Apparently he couldn't concoct a single sentence to define his ascent, couldn't muster a single phrase to describe the outlook along the Toiyabe crest. His Arc Dome language is terse, his verbs passive, his energy tightly reined.

One route to Arc Dome starts from Columbine Camp on the west side of the range and follows the Stewart Creek drainage, crisscrossing bogs, a year-round stream, and standing water. Red osier dogwood and aspen decorate a rich riparian zone where Basque sheepherders have carved a legacy of names and dates. Salvatore. Eustakio. 1913.

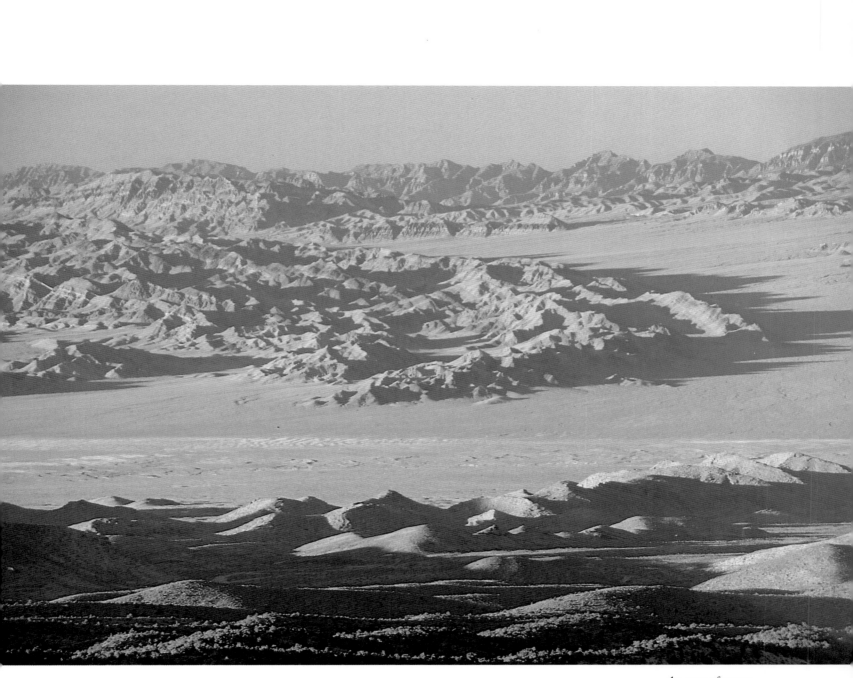

An army of ranges: the Sheep and Desert Ranges from the Spring Mountains, southern Nevada.

Fidel. Juan. F L My Last Year. Luis. Gorge. Their poignant artistry remains a Nevada testimony to loneliness and boredom. Past the aspen, I traversed toward a false crest where the land drops dramatically into the immense canyons of the North and South Twin. I saw miles of tempting backcountry but continued along the open ridgeline that eventually leads to the summit. The way undulates so gently that I watched my feet more to keep from stepping on the flowers than to keep my balance. There is no trail exactly, just a ribbon of buckwheat to follow. After an annoying dip that loses some precious elevation, switchbacks veer sharply up—twelve hundred feet in half a mile. The final yards are steep but not precipitous, rocky but not difficult. On top it's windy, but the views are outstanding. Not only the Reese River and the Shoshones, but Smoky Valley and the Toquima Range, Ione Wash and the Royston Hills stretch in shades of gray and blue and brown and green. I wondered as I sat there why Muir didn't hear the wind vibrate or remember the hawk beating its wings against the afternoon breeze, why he neglected the lichen coloring irregular orange and yellow patterns on the rocks, why—ignoring the panoramic sweep from ridge to playa—he failed to be moved by archetypal range and basin.

I decided to give the central Nevada ranges another look, to see why I find them so much more attractive than Muir could say. I explored four different canyons on the eastern slopes of the Toiyabes. Water, plenty of it, flows several thousand feet from the crest to the valley floor. The two Twin drainages, North and South, are steep-walled

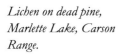

Lichen on dead pine, Marlette Lake, Carson Range.

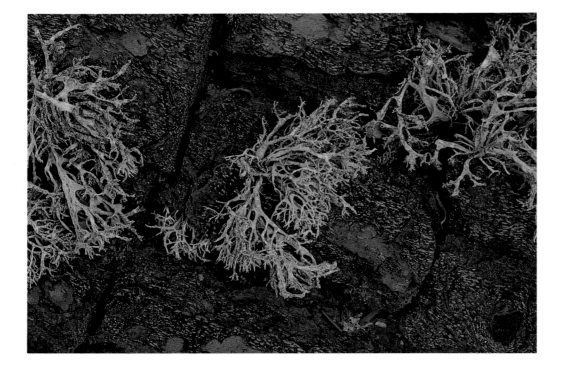

rocky cuts with waterfalls and beaver dams and half-trails that meander in and out of the cascading streams. Ophir is a different sort of canyon, where a century of mining has wholly changed its pristine character by excavating the steep walls and leaving heavy machinery behind. Kingston, broadest drainage of the four and a highly popular trout stream, actually boasts a decent road that crosses the top of the range and unwinds out the west side.

Near the top of Kingston Canyon, I followed the Toiyabe Crest Trail south toward Arc Dome nearly forty miles away. I began in a meadow so thick with grasses and so filled with murmuring ground bees that I picked my way with special care. The route soon curved up hillsides parched and dry in late July, where I flushed three sage grouse, who beat their wings in angry retreat as I approached. On the ridgeline, purple lupine flowered thickly, and I could find dried petals of yellow daisies along the trail. Off to my right, dark green irrigation circles punctuated the browns of the Reese River Valley; square ones marked the Big Smoky Valley to the east. I walked as far as a knob labeled 10579. My map showed other nameless knolls—10370, 10089, 11085—wrinkled papier-mâché mountains, pale green and pinkish cloth curtains, scalloped elevations—10001, 10863, 10997. Why had no one named these individual peaks? Why had John Muir chosen only a few taciturn words to describe them? I can't answer. While eating my lunch on 10579, I pondered the mystery—sitting in glittering quartzite rock, surrounded by purple lupine, in the company of hundreds of white and gold and black butterflies, gazing a hundred miles in each direction.

No two Nevada ranges are quite alike. The limestone ledges of the White Pine Range, for example, lure a hiker onto narrow, acrophobic bands of stone. I can't narrate a climb of Currant, its highest peak, because I was scared to death to complete the ascent. Such pinnacles are more formidable than sunwashed tundra and shale rockslides, challenging but accessible. Two friends who've climbed all forty-two Nevada peaks higher than 11,000 feet tell me they needed ropes only twice. I don't mean to imply, however, that Nevada mountains are docile. To the contrary, they remain difficult and distant—snowbound in winter, parchingly dry in summer, more often trail-less than user-friendly. On the other hand, they're far more attractive and complex than a highway glance might suggest.

Sometimes they're impenetrable; sometimes a glance is all that's allowed. I camped alongside the Desert Range, a narrow strand of mountains on the eastern edge of Nellis Air Force Base. Large signs forbade me to enter: AUTHORIZED PERSONNEL ONLY. ALL PUBLIC ENTRY PROHIBITED. I understand the Desert Range occasionally opens during hunting season, but more often it stands secretive and unexplored. Of course I wanted

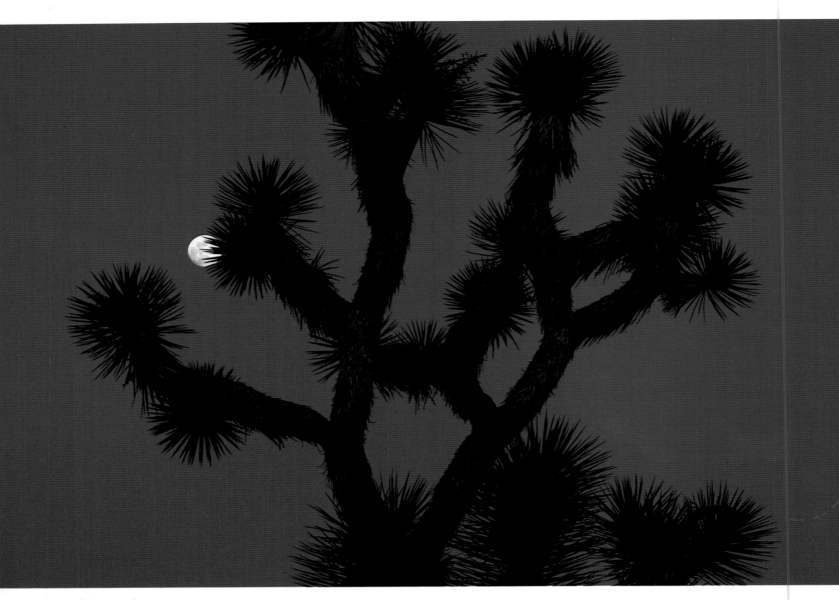

Joshua tree forests
begin where the Great
Basin Desert gives way
to the Mojave Desert.

to sneak past the boundary. Looking at the stubby fault-block ridge, I couldn't see much detail—barren rock so uplifted that its lines are nearly perpendicular, no vegetation beyond a single Joshua tree. I was curious, but since commercial flights aren't allowed in Nellis airspace and it's foolish to drive into a bombing range, I must guess the mysteries of the Desert Range only by analogy.

The Sheep Range—heart of the Desert National Wildlife Range—lies just east of the Desert Range. Its southeastern slopes, like the neighboring forbidden ones, are treeless uplifted limestone. Fossil Ridge, one more zigzag crest to the east, is equally dry. From a distance, anyone unfamiliar with southern Nevada might think the banded terrains ascetic and unwelcoming. Actually, as I explored the Sheep mountains, I found countless surprises. By analogy, I assume geographical and biological complexity in the off-limits Desert Range as well.

On the western flank of the Sheeps, I hiked to Wiregrass Spring Camp. Starting in a desert wash, trudging through a drought-stricken April environment of stressed cactus and flagging shrubs, I finished atop a knoll of quartz conglomerate where an evergreen forest filled my view. The distance between the two? Four miles. Near Wiregrass Spring, water seeped beneath leftover snow and bathed hanging gardens of moss, which spread down the limestone cliffs. The spring itself sits in a ponderosa grove with live trees as large as nineteenth-century loggers cut at Lake Tahoe. I tried to measure one too big for me to stretch my arms halfway around. It stood among dozens of other ponderosas, each more than a hundred feet high. One fallen trunk crossed from the left-hand side of the park almost to the cliff on the right.

Over the crest of the Sheep Range, an east-facing canyon dryly countermands the unusual pristine beauty of this one. Early settlers from the Moapa Valley cut most of the Sawmill Canyon ponderosas but, because they thought Wiregrass Spring too distant, no one logged the giant trees on the western side. When the Desert National Wildlife Range was established in 1936, the remaining ponderosas and white fir accordingly were protected. The 1,500 to 1,800 desert bighorn who inhabit the refuge's 1.5 million acres are protected, too. It amuses me to report that, knowing nothing about boundaries drawn in Washington, D.C., sheep roam the forbidden bombing range as well.

The Sheep Range encompasses all three habitats common to southern Nevada ranges. Desert shrub grows between 2,500 and 6,000 feet, piñon-juniper woodland develops between 6,000 and 7,500 feet, coniferous forest above that. I camped across from an alluvial fan known as Joe May Canyon, in the midst of desert shrub. The spring vegetation seemed especially dry—burnt-out cactus, yucca, Joshua trees, Spanish bayonet. Up the wash, flowers grew here and there, but I saw few signs of life. Someone

must have found sustenance in this canyon, though. I measured the biggest abandoned agave roasting pit I've ever seen—nearly thirty-five feet in diameter. I looked for animals, but found only cocoons pulsing with caterpillar threads. Sheep trails, sheep beds, sheep droppings—no sheep. Joe May's little brother canyon was a disappointment to me.

A high-clearance dirt road runs on the other side of the range between the Corn Creek Springs refuge headquarters and Highway 93, forty-seven miles to the northeast. Unlike most rough desert tracks, however, this one comes equipped with a travel guide and tourist signs—like YUCCA FOREST, planted to indicate flourishing Joshua trees. As the pamphlet suggested, I stopped for lunch at Peekaboo Canyon, where the road drops past cliffs with fossils and below caves in limestone. After that, I drove high enough to see juniper interspersed among the Joshua trees, then some woodland pine and, at Mormon Pass, even a few ponderosas that had escaped the loggers' saws. Wondering how another generation had gotten the ponderosas out, I tried to calculate the distances and the effort involved in skidding giant logs at least forty miles off the mountain, under a blazing sun, without power saws, without air conditioners.

As I drove each dirt-road mile, more ranges beckoned. Hayford Peak, Meadow Valley Mountains, Arrow Canyon Range, and Mormon Peak layered themselves along the dusty horizon. I wished for more time to explore the caterpillars of southern Nevada. While on average the mountains rising above the Mojave Desert are not as high as those ranges to the north, they're equally as isolated and formidable and flower-filled and enchanting. In all honesty, too, I wanted to see some sheep. Only in my imagination—and once along the Lake Mead Highway—have desert bighorn appeared. The last time I was in the Desert National Wildlife Range, the ewes were lambing in high, almost invisible places. Although I scanned the ridges with my binoculars, I saw no movement. The rams, herding together in bachelor groups, were supposed to be more sociable, but I couldn't find any of them either. Disappointed, I finally had to give up my search for a flesh-and-blood companion to my Ruby Crest Trail's mountain goat and her kid. As I followed the rocky dirt track toward the highway, I met a ranger coming the other direction. He smiled when I complained about not spotting any sheep. "Where you camped last night," he said laconically, "four days ago, seventeen bighorn grazed right past where you parked."

Ghosts

Tucked against the Schell Creek Range and looking across the Spring Valley basin, dinner eaten, dishes clean, cup of tea in hand, I was ready for nightfall. The setting sun cast soft alpenglow off the Snake Range to the east. The shadows deepened; the scenery and silence were vintage Nevada. When I spotted the tombstones, they seemed to belong. Three quarters of a mile away, what appeared to be a ghostly cemetery stood in silhouette. Maybe half a dozen markers half-buried in the sage, maybe a sagging wooden fence—it was hard to tell in the semidarkness and too late to investigate that evening.

The next morning I crossed the draw and pushed my way through the sagebrush. "N. L. Hughs a native of Missouri died Mar. 11, 1896 aged 63 years"; "James Doherty, died Oct. 21 1891 age 57 yrs"; "'T is finished! The conflict is past: The heaven-born spirit

is fled." There, ninety miles from Ely and a dozen dirt road miles from pavement, stood a cluster of marble tombstones that would befit Virginia City. Elegant scrollwork bordered the names, forgotten memorials to a handful of men who died a century before. Apparently no women and no children were buried there, for I could find markers only for males. "M. Killam died Feb 4 97 Born in Penn July 4 1820"—the precise etching cut deep into the marble.

I spent most of the morning looking for clues. I was sure I would discover a ghost town nearby, a cluster of half-ruined buildings, the remains of some walls, or at least a clearing in the stony soil. Near the cemetery I stumbled on an abandoned well but found few other relics of past inhabitants. No trace of a street, no sign of a disintegrating dwelling, nothing that resembled a once-thriving community. Up the mountainside, an old mine shaft collapsed in on itself, rusted pipe and a few timbers, dirt leached turquoise-green, an unused road overgrown with brush. But the mine was far from the cemetery site, and surely could not have sustained the wealth that paid for marble carving. Closer to where my truck was parked, a couple of other mine shafts were more clearly visible. In fact, I had camped quite near some broken stone walls. Even these, however, appeared too insignificant to have fostered such a memorial display.

opposite:
Abandoned outbuilding,
Belmont.

Aurum cemetery, above
Spring Valley.

The library back home partially solved the mystery. Between 1870 and 1910, the eastern slopes of the Schell Creek Range first promised gold, then silver, then copper. The mines played out quickly, though not before boardinghouses, saloons, a blacksmith shop, a post office, a store, and a ten-stamp mill had been built in Aurum. Nearby Piermont also boasted a ten-stamp mill, and a population of about four hundred inhabitants at its peak. Today you find almost nothing except the cemetery. How many forgotten graves guard Nevada's memories? More than anyone can guess, I suspect. Everywhere across the Silver State, ghosts have left their trails.

Some of the first ghosts swam in the inland sea that sloshed two hundred million years ago. Reptiles as long as fifty feet from head to tail patrolled the shallow waters until equatorial temperatures turned the gigantic ocean to mud. The ichthyosaurs literally were beached and then buried by limey waters, rocks, lava flows, ash, and mud. Erosion and an inquisitive geologist named Dr. Siemon Muller finally unearthed their petrified bones. During the 1950s and 1960s, excavations by Dr. Charles Camp and Dr. Samuel Welles from the University of California, Berkeley, located forty separate specimens in just a few acres. A state park, established in 1970, shows off some of the immense ichthyosaur fossils. Its showpiece is a single quarry where nine partial skeletons lie exactly where they were found. There you walk around remnants of a twenty-five-foot tail, six-foot fins, the jaw of a badly crushed skull, ribs, shoulder bones, flippers front and rear. A single mid-body vertebra measures six inches in diameter, three inches thick. A row of them ridges the soil. Each piece tilts downhill in the desert dirt, as if a school of fishlike reptiles were paddling toward deeper water when the hot sun toasted them into eternity.

It's hard to believe that the nation's driest landscape displays a sea monster as the state fossil. Nevada legislators could have chosen any one of a number of other possibilities, for the state is littered with Paleozoic remains. Bill Fiero, in *Geology of the Great Basin*, describes a variety of small-size foraminifera, sponges, coral, trilobites, bryozoa, brachiopods, pelecypods, snails, crinoids, and cephalopods. You find them lodged in the most unlikely limestone places. Atop Cathedral Rock, 8,600 feet above sea level, I stepped on a perfectly fluted white shell, a "brach" the size of my thumb. Embedded in the same rock was a slightly larger but equally delicate veined leaf. These tiny fossils contrast mightily with the mammoth and bison bones found at both ends of the state. Archaeologists from the Desert Research Institute recently dug tusks and an intact skull from a dusty northern site that contains partial remains of four or five other enormous mammoths, some vertebrae of extinct camels and horses, and even one juvenile tooth of a saber-toothed tiger. Currently cleaning the findings with toothbrushes and stabilizing them

*Prehistoric magic carved
on the rocks of Nevada:
Hickison Petroglyph
Recreation Area,
Simpson Park Mountains
(above); Atlatl Rock,
Valley of Fire (below).*

with resin, the DRI team plans someday to display the remains for the public. Meanwhile, excavations continue.

It is unclear if these mammals died before humans arrived in the Great Basin or if the two coexisted for a time. Archaeologists tell us, however, that humans have lived in this desert for close to 10,000 years. An exhibit alongside the ichthyosaur bones holds a Gypsum Cave projectile point found in nearby Union Canyon. Flaked in approximately 1300 B.C., the point is displayed next to notched and eared cherts dating from A.D. 500 to 1850. Ancestors of today's Paiute and Shoshone peoples have inhabited this part of central Nevada for centuries. They left a tangible imprint on the land by chipping, pecking, incising, scratching, and painting symbols into the rocks themselves. When Robert Heizer and Martin Baumhoff published what they thought was a definitive study of rock art, they recorded 99 petroglyph sites in Nevada. Alvin McLane, the most knowledgeable petroglyph person in the state today, reports more than 150 sites somewhere east of Sparks—he won't say where—and hundreds more located throughout the basin and range country. So it is clear that the 1962 survey sorely underestimated what actually lies hidden in Nevada's rocks. Though they documented the yellow, red, and white pictographs of Potts Cave, Heizer and Baumhoff missed a Wheeler Peak site 13,000 feet above sea level. Though they detailed four figures in White Pine's Katchina Rock Shelter, they knew nothing of the 82 sites recently discovered near Battle Mountain. Though they reproduced many of the drawings found not far from Reno on the cliffs of Lagomarsino Canyon, they didn't mention the ones I've seen on a Peavine rockfall an hour's walk from my house.

Many of us would keep pictograph and petroglyph sites secret, but certain places are easily accessible and even visitor-friendly. Just off Highway 50, for example, the BLM manages the Hickison Petroglyph Recreation Area. There you see a series of interlacing lines, curves, crisscrosses, and scrawls that a handy brochure says "may represent hunting or fertility magic—or they may merely be prehistoric graffiti or doodling." No one knows exactly when the glyphs were drawn there, or why, but they remain a ghostly hint of past activity in the Great Basin. Neither extensive nor glamorous, the Hickison symbols show off unpolished work older than the more finished artistry found elsewhere in the state.

Not far from Laughlin, thirty-foot rock art panels guard the mouth of Grapevine Canyon. In all the years I have explored Southwest deserts, I've never found another site—not even Utah's "Newspaper Rock"—decorated with as many figures. Mythology tells us that nearby Spirit Mountain, sacred to Yuman-speaking Native Americans, is the site where their ancestors emerged from the earth. For generations, Indian people paid

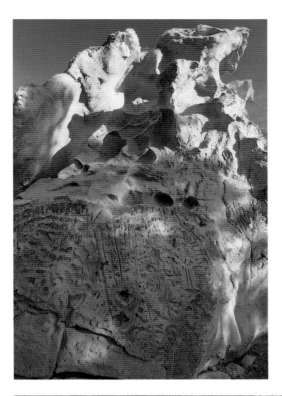

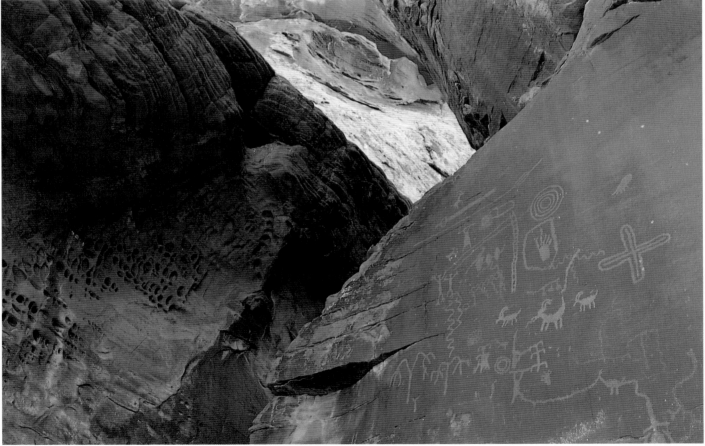

Prehistoric magic carved on the rocks of Nevada: Hickison Petroglyph Recreation Area, Simpson Park Mountains (above); Atlatl Rock, Valley of Fire (below).

with resin, the DRI team plans someday to display the remains for the public. Meanwhile, excavations continue.

It is unclear if these mammals died before humans arrived in the Great Basin or if the two coexisted for a time. Archaeologists tell us, however, that humans have lived in this desert for close to 10,000 years. An exhibit alongside the ichthyosaur bones holds a Gypsum Cave projectile point found in nearby Union Canyon. Flaked in approximately 1300 B.C., the point is displayed next to notched and eared cherts dating from A.D. 500 to 1850. Ancestors of today's Paiute and Shoshone peoples have inhabited this part of central Nevada for centuries. They left a tangible imprint on the land by chipping, pecking, incising, scratching, and painting symbols into the rocks themselves. When Robert Heizer and Martin Baumhoff published what they thought was a definitive study of rock art, they recorded 99 petroglyph sites in Nevada. Alvin McLane, the most knowledgeable petroglyph person in the state today, reports more than 150 sites somewhere east of Sparks—he won't say where—and hundreds more located throughout the basin and range country. So it is clear that the 1962 survey sorely underestimated what actually lies hidden in Nevada's rocks. Though they documented the yellow, red, and white pictographs of Potts Cave, Heizer and Baumhoff missed a Wheeler Peak site 13,000 feet above sea level. Though they detailed four figures in White Pine's Katchina Rock Shelter, they knew nothing of the 82 sites recently discovered near Battle Mountain. Though they reproduced many of the drawings found not far from Reno on the cliffs of Lagomarsino Canyon, they didn't mention the ones I've seen on a Peavine rockfall an hour's walk from my house.

Many of us would keep pictograph and petroglyph sites secret, but certain places are easily accessible and even visitor-friendly. Just off Highway 50, for example, the BLM manages the Hickison Petroglyph Recreation Area. There you see a series of interlacing lines, curves, crisscrosses, and scrawls that a handy brochure says "may represent hunting or fertility magic—or they may merely be prehistoric graffiti or doodling." No one knows exactly when the glyphs were drawn there, or why, but they remain a ghostly hint of past activity in the Great Basin. Neither extensive nor glamorous, the Hickison symbols show off unpolished work older than the more finished artistry found elsewhere in the state.

Not far from Laughlin, thirty-foot rock art panels guard the mouth of Grapevine Canyon. In all the years I have explored Southwest deserts, I've never found another site—not even Utah's "Newspaper Rock"—decorated with as many figures. Mythology tells us that nearby Spirit Mountain, sacred to Yuman-speaking Native Americans, is the site where their ancestors emerged from the earth. For generations, Indian people paid

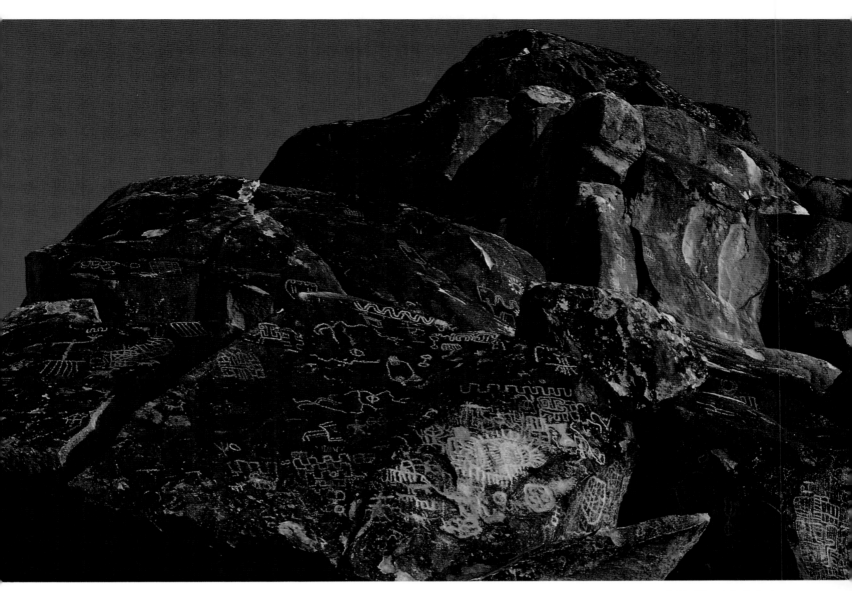

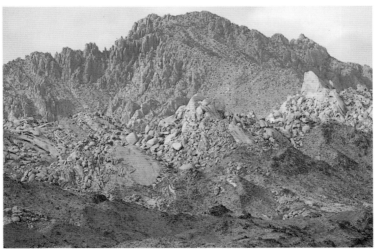

Spirit Mountain (below) guards the rock art at Grapevine Canyon in southernmost Nevada.

homage to the mountain's generative power by chipping symbols onto iron-stained walls, creating a gallery of forms and figures. Perhaps because of the canyon's proximity to Spirit Mountain and its ancient mythic heritage, prehistoric people incised more labyrinths and mazes than any other design. Some drawings circle and spiral concentrically inside themselves; others, square and rectangular, dead-end internally or else open either vertically or horizontally onto the rocks. Since anthropologists disagree about the symbolic meanings, I hesitate to suggest my personal interpretation. Yet it's easy for me to imagine the artists replicating labyrinthine passages between the underworld and fertile Grapevine Canyon, designing mazes between darkness and light.

Spirit Mountain invites such contemplation. The highest summit in what maps call the Newberry Mountains, it dominates the rest of the range. Spirit Mountain erupts from the earth. Giant boulders of irregular shapes and sizes spew down its sides in rugged disarray. Little greenery interrupts the brownness of the naked slopes. At sunset, but more especially just before dawn, the mountain glows with an inner transcendence. Ridgeline spires light up in a hazy interplay of light and shadow. If you sit and watch a sunrise, the raw power of the mountain compels you, not necessarily to climb to the top but to embrace its strength. I like to pretend that anyone who watches such daily and seasonal changes can appreciate Spirit Mountain's mythology.

It's easy for me to think I understand things about Grapevine Canyon too. Hunting symbols appear frequently. You'll find more atlatls incised into these walls than you'll see at the better-known "Atlatl Rock" in Valley of Fire State Park. One high panel shows several such throwing sticks side by side, each parallel hook etched deeply and precisely. Renderings of animals, however—especially the huntable desert bighorn—far outnumber implements of the chase. I couldn't begin to count the sheep that slouch, stand, prance, run, and leap up Grapevine Canyon walls, but I paid special attention to their poses. Long horns and short, curved horns and straight, heads tipped downward as if grazing, heads high as if running free, straight-bodied or sway-backed or possibly pregnant, legs stiff or bent, hoofed and hoofless, stances ordinary and imaginative, artistry simple and complex. One panel lines up five desert bighorn in a row, each in a slightly different posture, each dancing its way up the wall. Alive, eager, vibrant, they're the most sophisticated zoomorphs I saw in the canyon. And they're situated exactly where a hunter might have hidden in ambush, waiting for sheep and biding his time by figuring the rocks with magic.

Younger ghosts marked Nevada rocks in language more directly translatable. Where reddish cliffs point the way through High Rock Canyon, one pioneer chipped a permanent memorial to himself. "George N. Jaquith July the 16th 1852 Wis." I look at

George's letters, and wonder whether he liked Oregon better than Wisconsin. I don't know the answer. Such is the tantalizing fate of most Nevada ghosts, for they rarely leave enough evidence to tell a whole story.

I like to shadow the pioneers, especially along the route of the Lassen-Applegate Cutoff, perhaps because it winds through some of the most isolated territory around. This so-called shortcut was the way chosen by forty-niners and their followers who either mistrusted the promise of all that gold in California or misjudged the rumors they heard. Fearing one desert crossing and therefore naively selecting another, a number of parties left the Humboldt River and struck out toward the northwest along a path blazed by Peter Lassen and Jesse Applegate. Some sought the fertile fields of southern Oregon; others, a supposedly easier route to the mines. J. Goldsborough Bruff, who chose this less-traveled way, reported in his diary: "Ravines, gulches, & dry stony beds of winter torrents run down in every direction. The trail follows up one of these dry conduits, along a sandy pebbly bed; White and yellow quartz, chlorite slate, iron conglomerate, and dust, with porphyritic pebbles, characterize the approach to the pass in the mountains. Passed, on road, since we left the river, . . . any countless wheels, hubs, tires, and other fragments of wagons; ox-yokes, bows, chains, &c."

Because little changes in a "land of little rain," the vistas across northern Washoe County still resemble what Bruff saw in 1849. As a matter of fact, recent volunteers who signed the Lassen-Applegate Cutoff at half-mile intervals past the Black Rock and on through High Rock Canyon used this diary as one of their guides. Bruff's descriptive detail and his rough accompanying sketches make people want to stand where he stood and walk where he walked. Fortunately, not all of his details resurface in the 1990s. Just past Rabbit Hole Springs, he "counted 82 dead oxen, 2 dead horses, and 1 mule;—in an area of 1/10 of a mile." Then he added, "Of course the effluvia was any thing but agreeable." When I first moved to Nevada, a friend teased me about the wagon trail past Rabbit Hole Springs. In Nebraska, he said, a depression in the grass marks an old wagon route; in Nevada, instead of looking for a depression you look for a line where the sagebrush grows taller. He pointed away from the springs and chuckled—all that fertilizer, all that vegetation.

A scene J. Goldsborough Bruff drew with special accuracy lies just west of the Black Rock Desert crossing, where a present-day dirt road touches Fly Canyon. Wagon ruts are still visible. At the bottom of a short steep grade, shattered pieces of wood testify to what obviously was a difficult passage. Here, where the pioneers so cautiously slid their wagons, the cliffs look just like Bruff outlined them. Perhaps the forty-niners took little time for sight-seeing—Bruff doesn't mention many side trips—but Fly Canyon is worth inves-

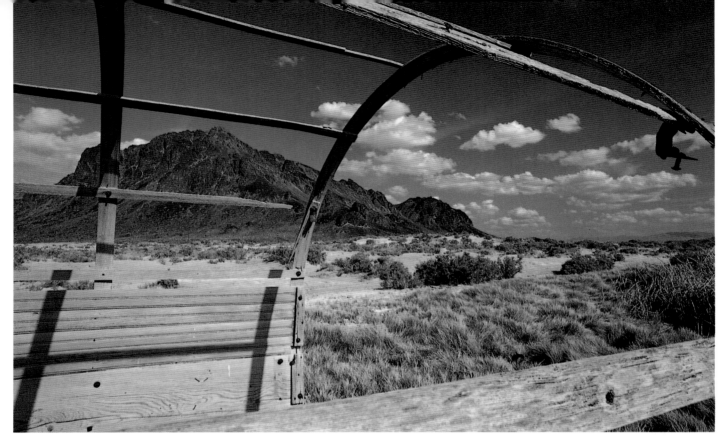

An abandoned sheep wagon along the Lassen-Applegate Cutoff, Black Rock Desert.

tigating. Climbing through the debris carried by high water, you circle past deep pools cut into the canyon floor. The largest is more than thirty feet in diameter; the smallest, less than a foot across. Some still hold water; some are dry. These potholes were carved by centuries of a powerful flow, which barely trickles now that drought has dried the upstream source. I've actually camped in the empty upper lakebed, once full, where grateful pioneers watered thirsty stock 150 years ago.

I try to imagine how a pioneer woman, trudging step by step across basin and range, might have judged the desert, and what, shading her eyes from the glare of an August sun, she might have seen. Weekends inside an air-conditioned pickup truck can't compare with a month of sun pounding on a faded sunbonnet. Crossing Nevada on foot must have been brutal. "The Dust!" exclaimed a doctor in 1850, "no person can have the least idea, by a written description—it certainly is intolerable—but that does not half express my meaning—we eat it, drink it, breath [*sic*] it, night and day, the atmosphere being loaded with it."

Nothing helped. "The river water which we have to use is detestable; it is fairly black and thick with mud and filth," wrote Henry Sterling Bloom, another emigrant that same

year. But Bloom's sense of humor prevailed. "There is one advantage one has in using it—it helps to thicken the soup which would be rather thin without it." Laughter helped the pioneers keep their sanity.

Hospitality as well as humor helped ease the way for later travelers. The parents of Nevada essayist Idah Meacham Strobridge ran a stage stop where the Lassen-Applegate Cutoff forks away from the Humboldt River. Mark Twain must have paused there, though he doesn't mention the Meacham place by name. I sensed the sparseness of early travel accommodations when I visited Mormon Well Spring, a stop located not on a pioneer trail but along a busy horse-and-buggy route north of Las Vegas. Now listed in the National Register of Historic Places, the old corral still stands. Perpendicular poles hung together with barbed wire form an almost perfect circle that must be seventy-five feet in diameter. Standing alongside the weathered wood and looking at the long-unused roads and tracks and paths leading every which way, I imagined the corral filled with livestock, horsemen bustling around its perimeter.

The earlier pioneers would have been grateful for such a welcome. As the forty-niners successfully navigated the last dry reaches of the northern part of the state, their diary entries sound notes of ecstasy. "The first trees large enough to form a shade we had seen in 1,100 miles," Jasper Hixson eagerly observed. "Men were seen to rush up, half crazed with thirst and embrace these noble old trees and weep as children." Hixson was describing the climax of the Carson River Route, a diagonal that took him and his family thirty miles south of the Truckee River and on toward Carson Pass. Emigrant Trail Marker CRR 12-A identifies this pioneer route as it crossed a place where the U.S. Army would build a post eleven years later. I stood on Fort Churchill's deserted grounds at sunset and thought about ghosts.

More than three hundred men once lived in fifty-eight buildings. The fort, which cost $179,000 to complete, remained active for only nine years. It's been abandoned for more than a century. Only a few ruins rim the hollow square, their walls disintegrating until preserved as part of the state park system. Not far from CRR 12-A, a similar post marks the pony express route that also ran along the Carson River. I imagined a cross-roads in the summer twilight—Indians, soldiers, pioneers, pony express riders, twentieth-century tourists. At Fort Churchill, as at many sites throughout the Silver State, ghosts come together.

Union Canyon, where ichthyosaur fossils and three-thousand-year-old projectile points rest side by side, was an 1863 ore site too. Although Union Ledge turned out to be the least important discovery in the region, it promised a path to nearby lodes—Ione, Grantsville, Berlin. Union no longer exists, except for some signs indicating where build-

ings once stood and a single adobe house that seems immune to the elements. Walking past the house, I thought I heard someone inside. A lizard scrabbled up the tar-paper roof; a scrap of canvas blew against the vacant back window; somewhere a tin can rattled. No one was there, except Mesozoic and Native American ghosts, and the shell of a house where a sign said the Josephs, then the Waites, then the Smiths once lived.

Berlin, two miles southwest of Union, like its predecessor has been adopted by Nevada as part of the Berlin Ichthyosaur State Park. The Berlin mill, coated with fresh preservative, boasts a new wall, a new ceiling, and new stairs inside. Shawn Hall's *Guide to Ghost Towns and Mining Camps of Nye County, Nevada* reports that it actually has been restored to "working shape." Some other buildings—the hoist shack, the stage station, the machine shop, the blacksmith's shop—remain relatively intact, while a few—Bob Johnson's saloon, Angela's brothel, Gregoria Ascargorta's boardinghouse—consist only of partial rock walls and piles of weathered wood. Although people visit Berlin each day, I've never seen more than a few at a time. On the whole, it's relatively quiet. Inside the machine shop, a board taps irregularly; outside, the tin roof lifts in the wind. A squeak of protective plastic rattles the empty windowpane of the blacksmith's shop. A door blows against its doorsill, while barbed wire scrapes the back wall. A sharp desert wind rustles the sage.

Gabbs, twenty miles away, is not a ghost town. Just last month I bought gas there. But the Premier Western Operations mine that dug into the nearby hillside is closed now, and Gabbs seems to shrink each time I visit. The mine buildings, red brick and skeletal concrete, remind me of 1930s New Hampshire shoe factories, empty and forlorn, their facades layered with the grays of death. Which actually is the ghost town? Berlin, coated with fresh paint and functionally saved for tourists, or fading Gabbs?

Nevada Coates, who looks after the deserted remains of a place called Tybo, says there's no such thing as a ghost town. Some might call Tybo a ghost town, he grumbles, but it isn't. Nevada Coates lives there, he owns property there, and, as he says, he's not a 240-pound ghost!

Discounting the bearded caretaker's protests, Tybo houses generations of ghosts. Its very name pejoratively means "white man" or "white man's district" in Shoshone. An 1870 silver discovery led to an 1874 boom, which, in turn, led to the 1879 failure of the Tybo Consolidated Mining Company. Revivals in 1901, 1906, and 1917–20 failed too, as did a 1930s lead-zinc operation that finally closed in 1944. A newly placed sign says Alta Gold presently owns the mineral rights, but they've done nothing near the site except hire a watchman. Two miles up Tybo Canyon, a pair of pristine charcoal kilns stand undamaged, their Italian-crafted rock walls hardly darkened with use. Nearer town, time

Ruined miner's cabin at Tybo, Hot Creek Range.

New ghosts intrude on the old: rusting machinery, Hamilton.

opposite:
A midden of rusted cans outside an abandoned miner's homestead, Cortez mining district.

has been crueler to the partial walls of a brick schoolhouse built on a foundation of stones. The only other brick structure, the Trowbridge Store, is crumbling too, although props inside and out keep it from falling over. A 1935 photograph in Stanley W. Paher's *Nevada Ghost Towns and Mining Camps* shows the hoist house, the head frame over the shaft, crushers, flotation mill, conveyers, the company general offices, the commissary, the superintendent's home, and the men's dormitory. Sixty years later, only the hoist and head frame are relatively intact, although mosaic rock sidings, concrete foundations, iron pipes, machinery debris, and piles of black charcoal scatter down the hill.

Somewhere else, I happened upon a miner's cabin slouched against a hillside. Its tin roof tipped sideways by winter snows and its sides bowed out, the shack nonetheless leaned upright, its contents untouched. Someone had painted the door a cheerful yellow and the window trim barn red. I stepped inside. Wallpaper made of flattened beer cases graced the interior walls; an empty Old Heritage bottle, dozens of rusted beer cans, and a stack of Prince Albert tobacco tins filled one corner. From the combination, I drew some conclusions about life here at the nine-thousand-foot-elevation level. The cabin's furnishings were timeworn and the kitchenware rusty with age, but I could see everything a hand-to-mouth prospector might need. A wooden bed frame, with springs intact; one large table, a smaller folding table, and a stool; a regulation cast-iron stove; two buckets, one for drinking water, one for bathing; a coffeepot, a skillet, plates, rusty silverware; an axe head; even a pair of boots and some torn khaki trousers. Only one window was broken, and the dirt floor looked almost clean.

A dugout behind the cabin would keep perishables cool. I wanted to go inside, but thought the dirt walls too unstable and feared what might live there now. A second cabin, higher up the slope, had fared less well than the one with the yellow door. More fully exposed to the weather, it had totally collapsed. Nearby tailings told the story of a mine long since played out—one large shaft fallen in on itself, a smaller shaft up higher, a few twisted rails. While snowmelt east of the mine was stained both brown and a sickly green, a creek lush with saxifrage bubbled from a year-round spring beside the cabin.

I camped for two nights in the meadow just north of the shack, where a panoramic view included snowdrifts still covering much of the landscape. I could pretend a wintry existence in that long-deserted place. What seemed charming in summer must have been hellish at other times of year. I imagined a temperature fifty, sixty, maybe even a hundred degrees colder than my July weather, then decided the men must have wintered elsewhere. This spot was too isolated, and probably buried half the year by wind-driven snow. Looking at the site—battered tin roofs, quaint red windowsills, dirty tailings and rusted rails—I wondered why I find old mining relics so abstractly romantic. I tested adjectives like "forlorn," "winsome," "rustic," "picturesque," and "quaint," even as I rejected terms like "pollution," "degradation," and "scars on the land."

Here was a two-bit mining operation launched with the same spirit as a mega-mining operation today. A jackpot mentality drove these prospectors, just as a strike-it-rich mind-set propels the corporations that work the Carlin Trend. This particular camp didn't bother me, though, because it fit with the wilderness, its scope narrow, its intrusiveness focused. I liked this lonesome place. Today's mines are different. At Goldstrike, less than two hundred miles away, trucks haul 22,000 tons of rock every hour from a pit eight hundred feet deep. For every gold bar, 125,000 tons of rock waste must be dug, crushed, leached, and then left somewhere. Projections say the pit eventually will double or even triple in size. I don't know exactly where the excavated earth will come to rest, but I do know the landscape will look very different. It already does. Maybe it's a matter of magnitude: small-scale digs, little lizards sleeping benignly in the sun; monolithic operations, more like voracious ichthyosaurs, wide awake and on the move.

You see a juxtaposition of old and new at Rhyolite, one of Nevada's better-known ghost towns because of its proximity to Death Valley. Rhyolite boomed in the early 1900s. In six short years it grew to be Nevada's second-largest city, with as many as 12,000 men, women, and children living there. The boomtown had three newspapers, two electric light plants, a hospital, an opera house, an ice cream parlor, even a stock exchange. Then people left, and Rhyolite began to fall back into the creosote and sage. Many walls still stand partially upright, so the deserted streets make a splendid photo-

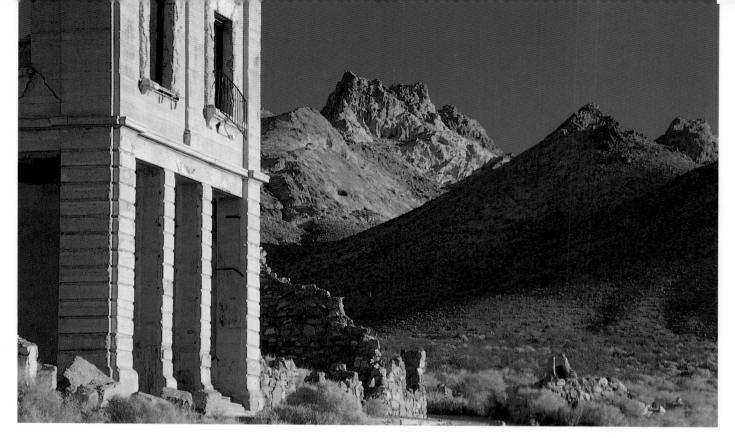

graphic backdrop. Looking from inside one ruin through the walls of another to the desert beyond gives perspective to the decay.

Two well-photographed buildings remain almost intact. Perhaps the most remarkable structure is the bottle house built by Tom Kelly in 1906, with walls made from thousands of unbroken beer and liquor bottles. All that glass, and yet it's dark inside, almost gloomy. More ostentatious is the railway station, a neo–Southern California structure with green rococo ornamentation. Shabby, unpainted and unoccupied, the depot shows its age. A barbed-wire-and-chain-link fence protects the structure—from souvenir hunters, I guess. Parked in the depot's shadow for an hour one Wednesday afternoon, I counted cars from six different states. One family didn't speak English. Two others never got out of their cars. Perhaps they didn't notice the view.

A 1990s mining operation almost surrounds the ghosts of Rhyolite. Beyond the main street, a productive Canadian mine scallops the mountainside and exposes tons of raw earth. Three miles away, on the Death Valley highway, where drivers and passengers first glimpse an edge of the gargantuan excavation, a sign used to say proudly:

MINING AND RECLAMATION IT WORKS FOR NEVADA.

Someone recently took the sign down.

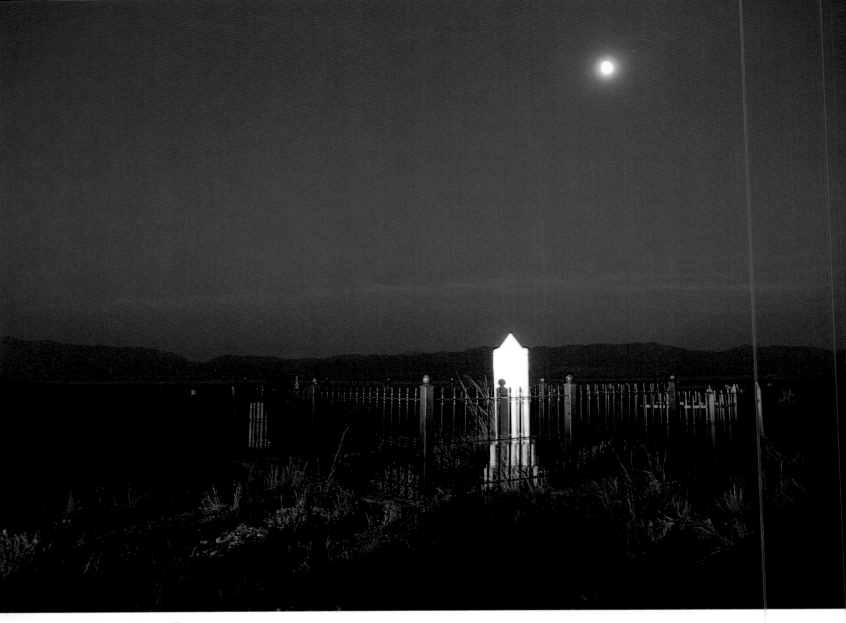

Spirits cast their spells in Tuscarora's cemetery at moonrise.

The curmudgeon in me prefers the old ways. I also fancy ghost towns farther off the beaten track, where lonely spirits cast their spells. Imagine life in White Pine County's Hamilton—a population of 30 in 1868, 10,000 in 1869, 4,000 in 1870, 500 in 1873, empty in 1950, 75 in 1980, empty again in 1994. A seesaw of people instead of a bell-shaped curve. Twenty years ago I spent a weekend camped not far from the spot where a large sign now insists: PRIVATE PROPERTY NO CAMPING IN HAMILTON. Waking to a chilly dawn, I walked up and down streets where so many strolled before me, in and out of crumpled brick buildings where commerce briefly flourished. More walls were standing upright then, though intricate brick archwork still testifies to masonry's longevity. Today, new ghosts intrude.

Another Hamilton, just as deserted but much less picturesque, usurps the surroundings. Torn curtains flap from the broken windows of four abandoned prefab trailers. An aluminum storage shed, with a door the size of an eighteen-wheeler, sits alongside five substantial vats marked "Treasure Hill." Beyond the shed and a nearby heap of rusting pulleys, an abandoned leach pond stretches north and south. The place, deserted once again, looks haunted in a different way.

I'm not so naive as to believe that the nineteenth-century excavations weren't invasive—one look at the nearby denuded Treasure Hill proves their voraciousness—but the early prospectors left behind a mountain instead of an open pit, a township of brick instead of plastic, a cemetery with marble tombstones instead of a monument to engineering innovation. The same holds true in Rhyolite, in Berlin and neighboring Gabbs, in Tybo, in the landscape around that yellow-doored cabin and its antithesis, the Carlin Trend. Where prospectors once pockmarked the land and left behind what we characterize as romantic relics of the past, bulldozers now gouge the depths and leave behind almost nothing. In some places, even mountains disappear.

Like most Nevada ghost towns, Hamilton is guarded by a cemetery. Legible marble monuments and illegible wooden ones cluster together, memorials to women and children as well as men. "In Memory of Albert B. Charles, A Native of Plattsburg, NY, Died in Hamilton, Nev, Dec 6, 1869 Aged 43 years"; "I.H.S. In Memory of Mary Casey, Died June 13 1870, A Native of Cambridge Mass. Aged 19 years, Erected to her memory by her esteemed friend Isaac Phillips"; "Umberto Lani, Age 4 yrs 9 mos, Sweet be your rest." A spectacular view, extending every direction from the cemetery, includes playa, round-shouldered mountains, a town with a double life—brick and stone walls, turquoise and green trailers, wrought iron fences and wooden pickets, a hundred-acre leach pond, plastic commemorative flowers and wild serviceberry in bloom. "Arthur Timson, Born July 27, 1873, Died Jan 6, 1898, Sweet be your sleep, Arthur, my darling boy." Miners are the phantoms of nineteenth-century Hamilton, but the landscape is the real ghost now. Mountains, crushed today and disappearing, are New Age Nevada ghosts, converging with the old.

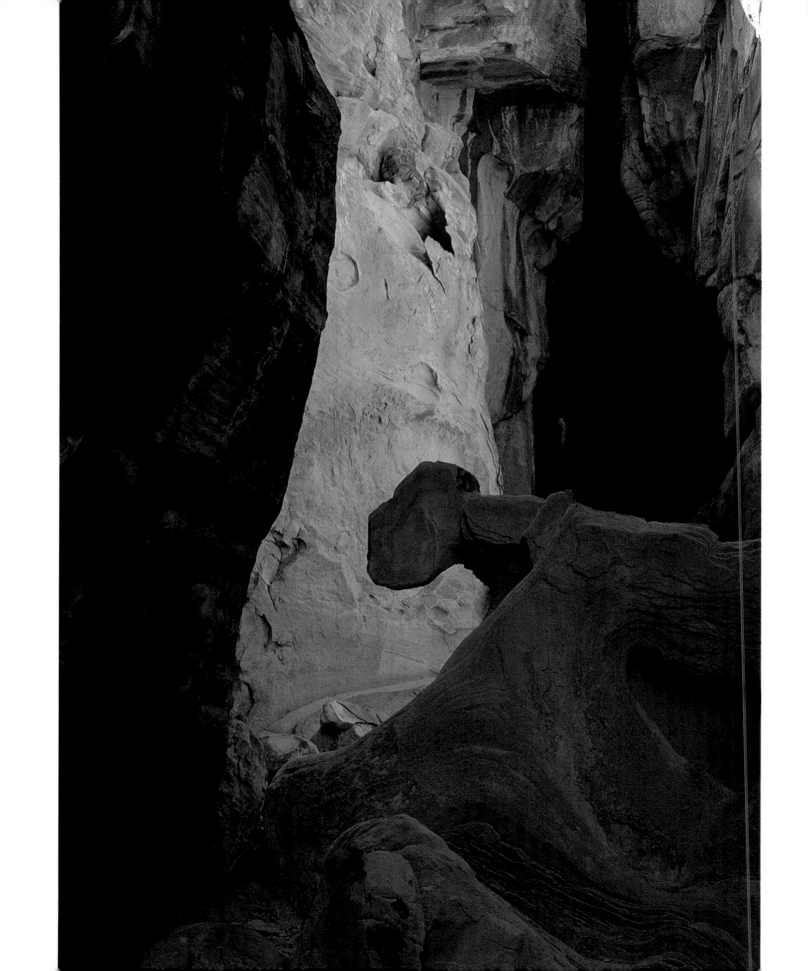

Treasures

Nevada's history and Nevada's nickname go hand in hand. The Silver State's story repeats cycles of fortunes made and lost, townships platted and forgotten, bonanzas and bankruptcy, use and disuse, booms and busts. Nevada's 1864 alignment depended on mineral wealth, for the United States hastened to admit it to the Union only after Congress understood that Nevada statehood and the Comstock Lode might support the North's Civil War efforts. Eastern politicians coveted western silver. Treasure need not be so narrowly defined, however. Instead of assaying silver, gold, copper, lead, zinc, borax, or even diatomaceous earth as treasures, I think about the places where those minerals lie. Remembering colors and water and basins and ranges and ghosts, I picture Nevada's real mother lode. Not ore but the landscape itself.

Sandstone slots and whimsical forms in southern Nevada's Muddy Mountains.

99

Peach Peak. A colorful apricot mountain beside what's called a charcoal basin, where I found scarlet-veined bitterroot blossoming beside a neglected claimstake. The Truckee River. Even inside Reno's city limits, a skillful or lucky angler can hook a fourteen-inch trout for dinner. Railroad Valley. Ruddy ducks and hooded mergansers nest comfortably in protected habitat just a few miles from the only producing oil wells in the state. The Spring Mountains. A high-altitude winter retreat for Las Vegas skiers and a cool summer respite for hikers who share the ridges with mule deer, Clark's nutcrackers, white fir, and 18,000 acres of bristlecones. Nye County's Golden Arrow, Silver Bow, Reveille, Belmont, Bellehelen; abandoned hoists, a stamp mill, a crumbling smelter tower, a brick courthouse, piles of weathered boards, stone walls unattended. Their names romantic; their ruins testimony to the fluctuations of mineral wealth.

While I personally value all these Nevada treasures, Great Basin National Park is the first nonmonetary one recognized by the rest of the country. After more than forty years of debate, Congress finally acknowledged the distinct characteristics and merits of a high desert national park. On October 27, 1986, federal legislation created one in the Snake Range of eastern Nevada, 120 square miles that include the former Lehman Caves national monument, stands of aged bristlecone pines, lakes, a unique rock glacier, and three of the four tallest mountains in the state. Now the National Park Service directs tourists toward scenic spots the rest of us have known about for years.

I can't recall when I first climbed Wheeler Peak, although it must have been sometime in the early 1970s. I remember the cloudless day, because people had warned me about summer storms and strong winds that sweep the knife ridge near the top. Contrary to what others had experienced, our weather stayed perfectly calm. We enjoyed our lunches under clear skies, happily sunning ourselves above the cirque that distinguishes the 13,063-foot summit and looking straight ahead at more mountains almost as high. Jeff Davis, 12,771; Baker, 12,298; Pyramid, 11,926; each ridged with lingering snow, steep rockfalls, and stunted alpine trees. Though rugged, Wheeler differs from such grand company. Up close, as well as from a distance, the tallest Snake looks as if someone took a bite out of an ice cream cone—concave marshmallow, streaks of vanilla and chocolate truffles. I think of Wheeler as an extravagant dessert because I've never battled a Snake Range storm. When I climbed Wheeler again a decade later, I experienced the same calm cloudless skies.

Neither time did we share the summit with other parties. Since a national park draws many more visitors than a national monument does, I probably can't make a solitary summit trek today. Nor can I camp in quite the same way. Woodchopping at 5:20 A.M., a loud radio two hours later, and interminable sounds of a bouncing basketball

punctuated my last overnight stay in Upper Lehman Creek campground. I have fonder memories from the past, I guess. One August we feasted on watermelon. Since that was a time when we carried our own garbage away, we bagged the rinds and set them behind the truck. At 3:00 A.M. a skunk began a watermelon snack. At 3:01 A.M. our dog defended the watermelon. At 3:02 A.M. she thought better of her actions and leaped back into bed with her humans. We spent the next two hours washing the dog in ketchup, rinsing her, washing her again by the light of the moon. The ingrate threw up on our sleeping bags, and I can't begin to describe the look on the Austin service station attendant's face when we stopped for gas the next day.

We joined a Lehman Caves tour the afternoon before the watermelon episode, when we smelled more like campers. I go into the caves every time I'm near the park because their mysterious underground world fascinates me. Last year a ranger took me into the Gothic Palace without other visitors, then turned off his flashlight. I stood quietly, hardly breathing, and listened to the blackness. I found myself straining to see nothing, like I strain to hear nothing in the Black Rock Desert. I imagined shadows that weren't there. Although I couldn't penetrate the dark, I heard sounds emerge—drip, plunk, drop, plunk. Staccato, arrhythmic water fell from stalactite to stalagmite, from cave ceiling to floor. One droplet brushed my cheek. Just as he does for tour groups— but after a longer silent time—the ranger interrupted the blackness by slowly playing a beam of light on the formations. While filigreed goblins flickered and half-figures ghost-danced in the shadows, I thought of *Phantom of the Opera*, and shivered in the damp underground air.

Entrances to more than seventy-five other caves dot the nearby canyons. This whole area, rich in calcium carbonate, heated up when the Snake Range uplifted until, approximately twenty million years ago, the lower slopes changed into low-grade marble and mixed with Pole Canyon limestone. Slow trickles of water began seeping down into the new amalgam, first opening spaces and then filling them with decorative columns, drapery, flowstone, stalactites and stalagmites, helictites, popcorn, spurs, spaghetti, cave bacon, shields. Cavers regard shields as the distinguishing feature of Lehman Caves. Both the ranger and a park guidebook describe shields as massive clamshells, but I see their flat tops angling against ceiling and wall, with calcite icicles hanging irregularly beneath, and I imagine not shells but giant mandellas. Genuine mandellas, used ceremonially by Plains Indian people, are made of buffalo hide, rabbit fur, and eagle feathers, and symbolize prosperity, happiness, and good luck. Specially crafted native artifacts, these calcite mandellas adorn an underground gallery decorated with cave geodes, transparent crystal, glittering quartz, and cave opulence.

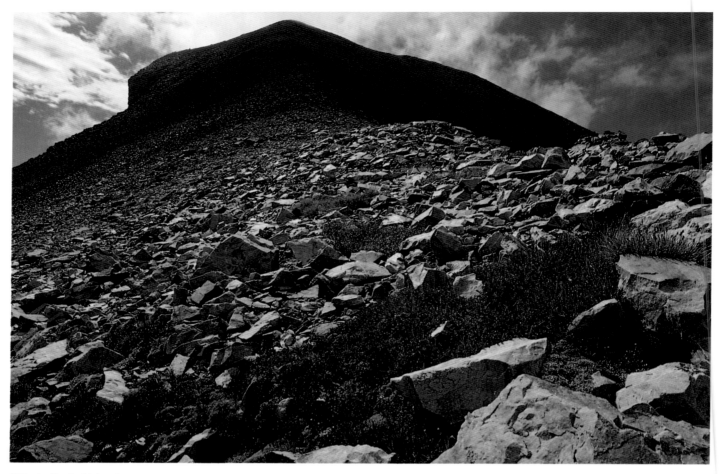

Wheeler Peak, high point of Great Basin National Park. Summit trail (above); glacially carved cirque (below).

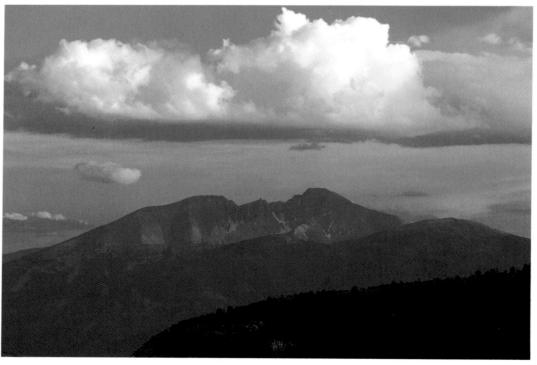

It makes sense to include such a gem as Lehman Caves in a national park, but it's odd to create a Great Basin National Park without a basin. Due to complicated political compromises, Congress drew park boundaries that embrace only part of the Snake Range and omit the Snake Valley to the east, Spring Valley to the west, and even a nearby playa facetiously named Baking Powder Flat. So a key distinguishing feature of Great Basin terrain is missing from a Great Basin park. Missing, too, is the northern half of the range, which is administered separately by the U.S. Forest Service. The Mount Moriah Wilderness, an 82,000-acre roadless area that includes Wheeler's 12,050-foot sister peak and unique alpine topography, was deemed a worthy wilderness but unfortunately excluded from national park status.

High on Mount Moriah, nearly 11,000 feet above sea level, sits a flat shelf the size of 6,500 football fields side by side. An Ely Ranger District map calls "The Table" a 7,000-acre meadow, but I think "tundra" is a more accurate label. The table floor, rocky but well cushioned with low vegetation and summer flowers, has been different each time I've seen it—a plate spread with melted butter, a dish of white china, a brown Frisbee rippled from sitting too long in the sun. Bright orange lichen splash the rocks, as if someone had shaken a paintbrush, while seasonal plants poke through the soil. I've seen The Table almost colorless, with ice patches for decoration; I've seen it awash with buttercups, with dwarf purple columbine, with white daisies and lilies, with aster and phlox. The last time I walked there, pollen brushed my hiking boots with gold.

Contrary to my Wheeler experiences but more typical of the Great Basin, the wind never seems to stop on Moriah. For a windbreak, I used the gnarled trunk of a bristlecone pine. These centuries-old trees cling longer to life when conditions are most severe. Given a protected location, they die after three or four hundred years; given a precarious one, they may live for three or four thousand. This particular bristlecone, corkscrewed to compensate for tempestuous elements, looked middle-aged. A seedling when Rome fell, perhaps; an adolescent during the Norman Conquest. Its thick trunk split into two personalities, one of pale sculpted driftwood, the other of green branches burred with bottlebrush needles, tiny young red cones and more mature black-gray ones. The living fork—which exuded pitch and good health—rested on the dying, the two symbiotically entwined. As I leaned into its shelter, I realized that, while I look to the twenty-first century, this tree easily may live to see the thirty-first.

Behind me, the massif of Moriah raised rocky and bare. In front, several thousand feet lower, dry alkali glittered in the sun. One year I drove to a trailhead just two steep miles west of The Table, negotiating a rough road that parachutes between mountain and valley. Another time four of us took a longer route, backpacking up Hendrys Creek

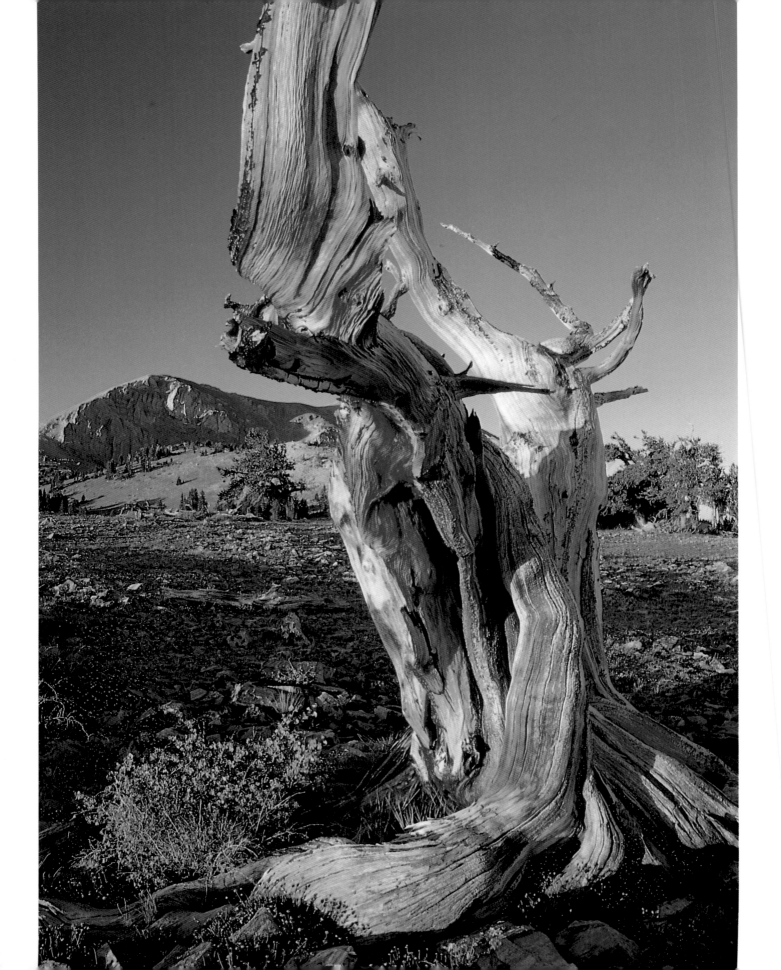

from an old quarry where we'd parked. On that trip one of my friends inadvertently walked up behind a young cougar stalking its breakfast. When she yelled, "Watch out!" the victim escaped. The mountain lion turned and glowered, as if to say a human might be a substitute meal, then silently loped away. I spent most of that trip looking everywhere for another cat and contemplating what we mean by "wildness" and "wilderness" in the twentieth century.

Even though Congress gives wilderness designation to places like Jarbidge and Mount Moriah, "wilderness" in the old-fashioned sense of the word no longer exists in the lower forty-eight states. I'm sure the Moriah mountain lion population would agree. No matter where I hike in Nevada, for example, a cougar is never far from anthropocentric company and I'm never more than a few hours' walk from a dirt road. Two-tracks seem to contour everywhere. Finding one doesn't necessarily mean people live nearby, but it suggests that at one time human beings set foot—or vehicle—on much of Nevada's landscape. Nonetheless, a large percentage of that landscape is distant, undeveloped, and wild.

The 1964 Wilderness Act decreed certain federal lands as wilderness and ordered that others be evaluated for their wilderness characteristics. After a 1980 inventory, the Bureau of Land Management suggested 111 Wilderness Study Areas in Nevada, a total of 5.1 million acres. Each WSA typically is a roadless area of at least five thousand acres that—in BLM language—appears affected primarily by forces of nature and provides opportunities for solitude or primitive recreation. For more than ten years, the BLM drafted environmental impact statements, considered "grandfathered use" such as grazing and mineral rights, looked at the U.S. Geological Survey assessments, analyzed "manageability," evaluated "wilderness values," and conducted ongoing public dialogue. Final recommendations still await presidential endorsement and congressional approval. Meanwhile, WSAs are fully protected.

One Wilderness Study Area, not far from pavement, shows off volcanic Nevada terrain. Nowhere else in the state looks so starkly volatile, with abrupt deep craters scooped from the earth, blasted pulverized rock, welded tuff, pointed cinder cones, lava, and volcanic residue. A passenger car will take you to Easy Chair Crater, Lunar Crater, and The Wall. Without leaving Highway 6, in fact, you can visit the Black Lava Flow, which abuts this WSA. The lava flow was generated when hot magma swelled inside a cinder cone, broke through, and oozed out. BLM signs describe the geologic event as "not very dramatic," but the heavy lava, like irregular chunks of coal, covers several acres north of the highway and is rich with black lava hods and scuttles large and small. When

Bristlecone pines on the 11,000-foot-high tundra of The Table, Mount Moriah Wilderness, Snake Range.

*Rising mist, Catnip
Reservoir, Charles
Sheldon National
Wildlife Refuge.*

you walk among them, you find bits of green pushing up, penetrating, breaking through the lava clusters. You feel like you're on a distant planet, stepping between galactic rocks.

Less accessible is a Wilderness Study Area located just a short drive from Las Vegas but so infrequently visited that I didn't see another bootprint. I omit its name because I promised southern Nevada friends I wouldn't lead readers directly there. Someone long ago put cairns along the safest route into this valley circled by stone, so if you know where to look it's not too hard to find the way. You can follow a wash into the valley too, but I don't recommend it. Not only is the route longer and—because it's softer—harder, but you miss the dramatic effects. When you climb over the rocks you see the scenery's scope all at once, a geologic window thrust open in a single moment.

I worked my way up peach-colored Aztec sandstone, past geometric sculptures and calico bluffs. Higher, to both right and left, thrust faults once pushed limestone gray sphinxes above the sandstone. The tallest protect a fenster, or window, in the rock, while others line the walls in picket-fence vigilance. Cresting the sandstone, I looked away from the ragged figures and surveyed the low valley itself. Kayenta formations float on a dry Mojave sea of creosote, grasses, sand, and limestone washed from above. They're huge shipwrecked icebergs, deep red, a different color and an older geological layer than the formations where I stood. Beyond the reds, more gray limestone culminates in a ridgeline leading to a single peak, taller than the rest. Giving up the panoramic view— one as striking as any I'd seen at anointed recreation sites nearby—I dropped onto a long-unused stock trail and began exploring the oval-shaped bowl.

Cattle once grazed there. A rancher even dammed two narrow slot canyons to secure water catch basins for his stock. His handiwork, long since abandoned to the weather, seemed almost natural, not the kind of human intrusion that might exempt this WSA from wilderness designation. The concrete slabs were unnoticeable below the round, oblong, and triangular windows that time had eroded into the sandstone above. Caves hung under some of the higher reaches, and I found one spot shielded by an extraterrestrial formation that looked just like E.T. More powerful than E.T. or the rancher's ghost or even the limestone guardians, however, were the prehistoric spirits. Rock art covers almost every suitable wall in the valley.

Because I had never seen a similar drawing anywhere else, I loved the Mickey Mouse panel. Its largest figure, like Disney's creation, has big ears and an unclear family history, either animal or human. A few feet away, a kokopeli—the hunchback flutist favored by many Southwest tribes—plays his rock art music. A multilegged centipede drawing crawls between them. As I wandered the western edge of the valley, I found more and more work—red painted linear pictographs with parallel lines drawn perpen-

dicularly, desert bighorn petroglyphs, snakes pecked with great care. One low panel portrayed four malformed sheep. Only their curved horns kept me from mistaking them for rocking horses. Some bug-shaped sheep had been drawn so recently that fresh stain had no time to reoxidize; some snakes were so old that revarnishing almost obscured them. Not far away, on the ceiling of an overhang tucked up in the sandstone, white handprints might signal the way to tinajas, for they gesture close to the only appreciable source of water during a dry summer. Two of the smooth catch basins, already evaporated, stood empty. The third, fifteen feet in diameter and sharply angled on the sides, held only a few feet of water. Sheep droppings covered the rocks above it, while hoofprints pointed the way to the single spot where an animal—or a ghost—could comfortably drink.

I spent the afternoon investigating the Kayenta formations. Though direct sun paled the deep morning reds, a persimmon color remained. One forty-foot panel resembled a stained-glass window framed by cracks in the stone. Horizontal lines drew close together near the bottom and again at the top, vertical sheens of white and orange stood lengthwise, and roseate magenta colored the left-hand side. Whites helped the reds glow internally, an inner candle adding depth and saturation. The piece belonged in a cathedral. Through eroded slits on either side I rediscovered the background cascade of dark limestone cliffs. My eyes fooled me when I looked at the horizon, for I perceived a darker blue silhouette paralleling the skyline, as if two ridges protected the valley instead of one.

I tested various observation posts. Standing on top of a formation, I felt powerful. When I looked down on the valley floor, I assimilated the grandeur of the rocks. Everything below me—a lemonade berry, desert almond, a prickly pear, the uneven underground route of a kangaroo rat—seemed remote and insignificant. Sitting in the middle of a formation was different, like hiding in a womb, I decided. When surrounded by the shapes and colors, I felt protected and much more intimately connected. I listened and I watched more closely. A colony of ants paraded in single file, back and forth beside my right boot. Thin leaves pushed greenly from a narrow crack on my left. Two ravens conducted a courtship overhead, bowing and cawing and flapping at each other. A jet contrail and another airplane's engine echo interrupted my thoughts by reminding me of a mechanized world I'd forgotten for a few hours.

I hiked out of the valley at sunset. Left behind, the Kayenta rocks blushed wine-red, a ruddy contrast to their pale afternoon glow. Evening brought more sculpture into the scenery, as the lighter mid-valley sandstone showed more beehive striations, pillared curves, and sharper corners. Wishing for a more innovative vocabulary, I conjured a hundred platitudes to describe what I'd seen that day. But when my own sandstone track

dulled in the shadows, I forgot about colors and clichés. Instead, I kept repeating the last lines of Zane Grey's *Riders of the Purple Sage*: "Lassiter, roll the stone," begs Jane to protect their secret valley from intrusion. "Lassiter, roll the stone," I echoed. "Lassiter, roll the stone!"

Some of Nevada's distant scenery is so immense that no one could possibly seal off access, so remote that few visitors ever go there. If you drew a line north of Winnemucca and Elko, then looked for towns, you'd find fifteen on the official state map—thirteen of those with fewer than 250 people, the other two with a handful more. If you looked for roads you'd locate Highways 93 and 95 running north-south, plus a couple of paved secondary highways. The rest of the more than fourteen million acres? Dirt tracks and distance. It would take more lifetimes than I have left to visit every asset—Goose Creek, Trout Creek, Twentyone Mile Draw, Middle Stack Mountain, Tijuana John Peak, Mount Ichabod, the Bruneau River, Bull Run Creek, Maggie Summit, the Owyhee Desert, Little Owyhee River, Maiden Butte, Quinn River Lakes, Agate Point, New York Peak, Blue Lake, Massacre Lake, Catnip Mountain, Painted Point, and hundreds more with names as colorful as their surroundings. Some are so rugged and so far from services that wise travelers carry not only extra gas but two spare tires instead of the usual one. From firsthand experience, I can attest to the uneasiness that accompanies a flat. Forty-six miles from pavement, you sure hope you don't have a second puncture.

Flat tires occur frequently on dirt roads spiked with obsidian, like those traversing the Charles Sheldon National Wildlife Refuge in Nevada's northwest corner. Pronghorn, an American antelope with no dewclaws, prefer uncluttered horizons, so they like the high plateau country of northern Washoe County where they can spot danger and run unimpeded from their enemies. On what we used to call the Sheldon Antelope Range, hyperactive bucks and does "see and flee" for a hundred miles. One August at Swan Lake Reservoir, I surprised fifty or sixty pronghorns who did just that—stared for an instant, then wheeled en masse and hightailed it toward the horizon. Carousel creatures, their rear ends painted white, bounced up and down as they raced at speeds faster than the truck could follow. Later that same day, curiosity got the better of two lone bucks. They ran a dozen yards, stopped, looked back, trotted a dozen more. They never did disappear from sight.

Like the Desert National Wildlife Range at the opposite end of the state, the Sheldon's expanses are oriented more toward animals than humans. Yet people play a role in its wilderness well-being. An old-timer recollects that grass covered Badger Mountain when he first saw it in 1907. Now, after nearly a hundred years of "vegetation manipulation"—an Environmental Impact Study euphemism for livestock grazing—sagebrush

dominates Badger's slopes. When I spent two nights alongside Badger Cabin, I saw grass and June's leftover blue iris in the nearby meadow, but few other delicacies for pronghorn to eat. I guess the antelope agreed. While I camped there, only three pronghorn and one mule deer doe sampled the limited menu. Controlled burns can reverse the century-old grass-to-sagebrush process. Patches of green show where rangers set cool fires in spring and fall. Around the edges, forbs—a pronghorn buffet—are slowly supplanting bare dirt.

An anonymous benefactor recently bought key in-holdings, grazing permits, and water rights, then retired the land from domestic use. At the head of Virgin Canyon, three of those newly acquired allotments have been undisturbed for the past two years. Without cattle, the meadows already grow more verdant and lush. Great Basin wild rye stands taller than the hood of a truck, though eroded streambanks make driving difficult. A few years from now, as the cuts heal, the riparian zone will be so overgrown that vehicular travel should be impossible. Where the present two-track disappears completely, bank beavers take advantage of the solitude. Shallow beaver ponds surround an old wooden shack, its roof crushed by a falling aspen but its glass windows still intact, the last remnant of a human presence. Wedged against the shore are two sturdier stick homes for beavers.

Hiking back to the truck, I detoured up to a fingering aspen grove. On either side, although cheat grass still terraced fading cow paths, indigenous plants were reasserting themselves. Chokecherries grew thickly under the trees, and bright vermilion columbine edged a watery seep. Looking back down at the ponds I thought of Minnesota, but not for long. While so much water may be unusual in Nevada, the surrounding sagebrush belongs in the West, not in the North Woods. Such vegetation unmistakably characterizes an arid climate where drought is always possible. I'm told that forage availability on the Sheldon differs as much as 1200 percent between a wet twelve-month cycle and a dry one. When an exceptionally harsh winter follows several relatively snowless years, the animals are helpless. In January and February of 1993, for example, nearly a fourth of Sheldon's two thousand pronghorns perished.

Other Sheldon residents took a beating too. Sage grouse and a small bighorn population need as much nurturing as pronghorn. Refuge biologists released sheep in three separate Sheldon locations, and the bighorn seem to be adapting quickly in two of the three sites. Late one afternoon I discovered three muscular rams sashaying up a cliffside, their bodies camouflaged against the rocks. Like the antelope bucks, they ran a few paces and then looked back. Through my binoculars I viewed their curled horns, their strong shoulders, their pale rumps, their almost quizzical expressions. Then a ranger told me

Summer thunderheads over the Joshua tree forest, Hancock Summit, Delamar Mountains.

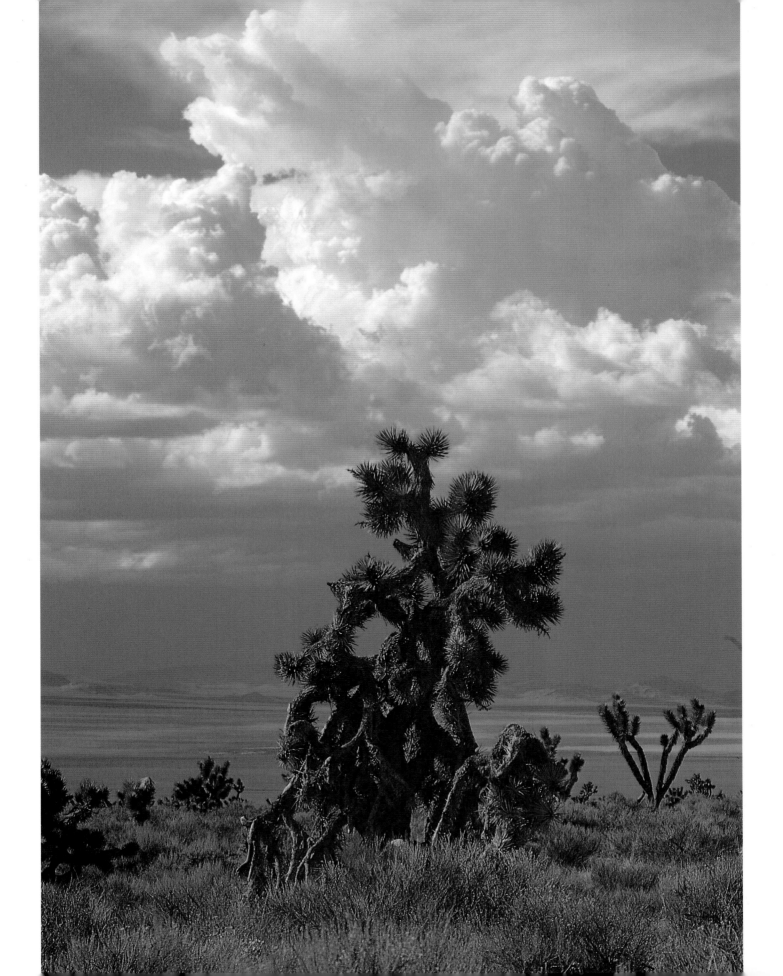

what I'd missed, minutes earlier, when thirteen other adults plus five woolly lambs had preceded my meager three.

I find California bighorn, like their southern desert relatives, elusive. Yet I treasure where they live, the spacious "see and flee" country that stretches from their Sheldon cliffs. Whether climbing a flank of Fish Creek Mountain or wandering north to Race Track Reservoir, I relish the long expanses of rangeland and sky. A summer wind brushes the sage and slips through dried grass long before I feel its warmth, ruffling the feathers of a Swainson's hawk perched silently nearby. As far as I can see, I'm the only human left. Nighttime on the Sheldon emphasizes the vastness. Without moonlight, a billion constellations star the midnight sky—the Milky Way a white rainbow from horizon to unseen horizon, the Big Dipper and Cassiopeia's "W", Orion's sturdy belt—more patterns than anyone can memorize, more heavens than anyone can forget.

The sky bridges all Nevada wilderness, including places some of us can't go. The military has preempted huge tracts for national defense purposes. The Nevada Test Site, neighboring Nellis Air Force Range, and land conscripted by the U.S. Naval Air Station in Fallon together total more than four million acres of land withdrawn from public access. In the middle of the state, a guardhouse protects a barred gate cemented in a ten-foot steel fence; beyond, what appear to be offices and barracks stand in governmental lines. Signs told me, KEEP OUT. Not a single human being brought life to the scene. Way out on the playa, taller structures glistened in the noon sun—a ghost enclave as extensive as downtown Tonopah, locked and apparently deserted. South of this science fiction complex, Groom Lake is a "remote desert test facility" undaunted by the end of the Cold War. No one knows exactly what goes on there, although 737s fly a dozen daily round-trips to and from Las Vegas. Citizen watchdog Glenn Campbell imagines they're building a spy plane of some sort, "a U-2 on steroids," he figuratively speculates. Recently the Air Force requested withdrawal of an additional four thousand acres to prevent public observers like Campbell from "spying."

While the complex southeast of Tonopah and the Groom Lake facility remain mysterious, the greater Nevada Test Site has a new 1990s posture. With appropriate credentials, I was permitted inside the gates. There, I perceived a chilling disjunction between wilderness and wildness. Beauty and the beast, I fear. The topography might be anywhere, with names like Silent Canyon, Buckboard Mesa, Banded Mountain, Gold Meadows, and Quartzite Ridge. Red Canyon tumbles magenta rocks down shiny black and amber folds. Conglomerates of black and yellow form brown mudballs in the dry wash. I climbed through red spires, then dropped into white and pink and beige and pale mauve tuff. A landscape befitting a national park, I dreamed, until I stepped over a shovel, a

bootprint, foil, a tire track, and a maze of disconnected wires. I also saw where soldiers drove tanks on maneuvers, where scientists perched to watch nuclear explosions. Wide-track swaths cut to a hilltop platform, then smashed straight to the basin below.

While I ate my lunch, I read my maps more carefully, and found sites like Plutonium Valley, Camera Station Butte, Parachute Canyon, News Knob, Groom Lake Road, and Smoky Blast Center. I could see three nuclear-made depressions from where I sat—Buster-Jangle Crater, Teapot Crater, Scooter Crater—and I could see Yucca Flat bomb towers too. I remembered a 1980s tour, when a guide pointed out bleachers where reporters and visiting dignitaries watched 1950s atomic blasts explode before their eyes. They wouldn't have seen the panorama I could see, because mushroom clouds would have blotted out their distances. Our guide then drove us to the bunkers, the bank vault, the cinder-block motel buffeted by megaton "devices." That was a wet year, when dark-stained mud oozed on the Frenchman Flat playa. I carefully kept the muck off my shoes.

Twenty miles away, another canyon forks namelessly. I hiked alone past an iron-stained cave hidden in puckered red conglomerates. The rest of the wash cut through khaki. Where the dry streambed finally ends at a cliff two hundred feet high, slabbed rock leans heavily on porous stone with hard eroded mud compartments. Seeking isolation, I failed. I heard trucks shifting gears, deep growls of machinery, drifts of a loud-speaker, a siren twice piercing the silence. Someone had flagged the hillside on my left. Backtracking, I followed the right-hand fork. White caves and yellow marked a path between tuff and darker limestone. Soft underfoot, the earth was the color of muslin. I forgot about khaki until I reached the ridgetop, where I looked directly down on a borrow pit, a sewage disposal, adits, a vent, and a radio tower. I also looked down on Camp 12, an outpost once teeming with life where, several years ago, I stood in a long cafeteria line and dodged cars on Mars Street, Neptune Street, and Antler Avenue. Now nearly deserted, Camp 12's parking lots stand empty. Only a handful of men dressed in white protective suits waited for something I can't define. Above Camp 12, manmade tunnels burrow deep in the mesas. Horizontal ones housed tactical nuclear weapons tests; perpendicular excavations, underground nuclear bombs. Once I plumbed the depths of what now is a national showpiece for the Department of Energy. Like any ordinary mine, Tunnel N has rough walls, a boxcar grinding over rails, darkness penetrated by fixed lighting, a slightly claustrophobic ambience. I wonder what the workers thought.

In truth, I find the Nevada Test Site an amazingly beautiful place, with its own basins and ranges, colors and water and ghosts. The road to Rainier Mesa, a 7,600-foot-

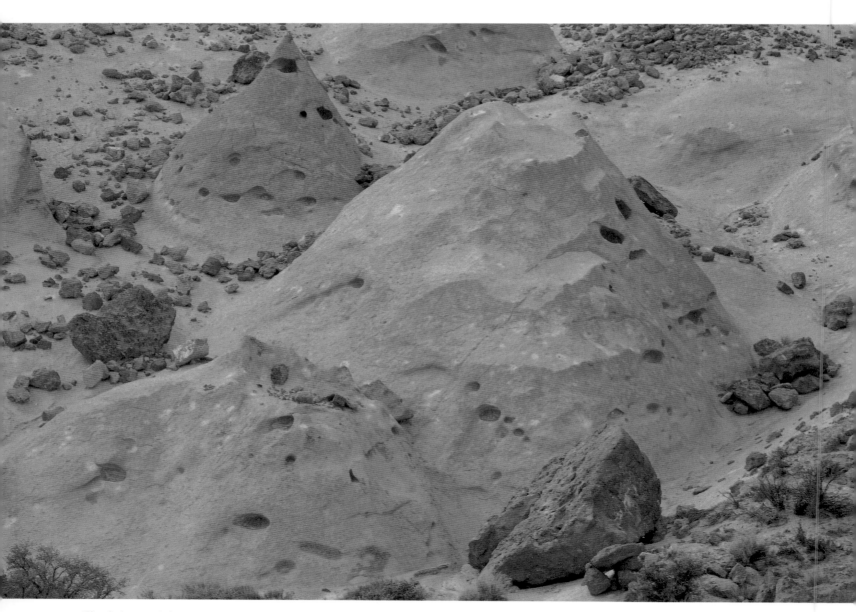

*Ghostly faces eroded
in tuff, Red Canyon,
Nevada Test Site.*

high plateau, circles above tuff ten to fifteen million years old. Like a Utah highway lifting itself through Capitol Reef, it traces puce cliffs, pink horizontal layers and folds, white perpendicular gargoyles. Not far from Stockade Wash stand cherrystone formations, a swirl of desert varnish, a tinaja with rock art. Only when I looked out the corner of my eye did I focus on a tunnel entrance cloistered in steel and cadaverous towers in the distance.

Rainier Mesa looks the way woodland Nevada once looked everywhere, with juniper, bunchgrass and buckwheat, deep thickets of pine. When I drove through the fresh green mosaic landscape, winter snow mounded under the trees. No one maintains the high roads, now that underground nuclear tests have been discontinued. I dodged snowdrifts and rocks and unattended potholes. Wireless telephone poles, unattached sensor wires, and useless copper strands signal the way to an aging DOE Repeater Site. There, standing by the metal trailer tipped with fifty-foot antennas and an even taller lightning rod, I again felt the Jekyll-and-Hyde personality of the Nevada Test Site. A cold wind blew cloud layers in from the north, past range after range painted in shades of winter blue. As far as I could see, I traced mountains to climb and playas to explore, space withdrawn from public access. Overhead, skeletal aluminum hummed discordant notes whenever the wind gusted—an eerie ghost lament for treasures found and lost.

At Tippipah Spring, NTS ghosts converged. Flaked obsidian, obviously worked by prehistoric people, nested alongside a worn-out house of sod and stone. An Antiquities Act sign cautioned souvenir hunters to keep their distance. I might be anywhere in the state, but a second look confirmed I wasn't far from Mercury. Hanging between white poles with red stripes another sign told me, if I understood the code, my exact military location—"16-7-c." A third sign warned of leftover explosives. Barbed wire coiled around posts and lay in disarray, while twisted sensor wires crisscrossed dirt roads leading to and from the spring. Black cliffs armored the closest hillside; tawny tuff lightened a far-off ridge. A low-flying helicopter drowned chukar conversation. Hyde and Jekyll every time I turned my head.

More United States citizens view the test site as a potential nuclear waste repository than imagine the landscape a treasure. A barren analysis led to the creation of NTS in the first place, and an ongoing misunderstanding of desert beauty suggests potential misuse by future generations. For me, this place is a microcosm of the way outsiders treat Nevada—an unfortunate misinterpretation of distance and space and earthtones and so-called emptiness, a regrettable assessment of what is valuable and what is not.

When mining the wealth of Silver State scenery, I've discovered that where I prospect makes no difference—a block or a mile from where I live or places so remote they're almost inaccessible; along a highway, down a dirt road, up a faint trail; hiking, strolling, even sitting. Almost anywhere in Nevada I can unbury earthtone treasures like the test site, a national wildlife refuge, a national park, a wilderness study area, or just a slivered canyon a mile or two from home.

Once, while camped high in a part of the Snake Range that Congress omitted from the national park, I watched a summer sun set through the leaves of a grove of mountain mahogany. The weathered trees, with their twisted trunks, leaves flat across the top, dead branches here and there, looked like wind-shaped Monterey cypress or distant African acacia. I couldn't decide. Instead of enjoying an ocean or a Serengeti setting, however, I looked out at basin and range. At my feet, rough limestone terraced toward gently curved meadows of green. To the southeast, treeless Moriah showed white cliffs at first, loomed brown until the sun disappeared, then blushed pink in alpenglow that spread both north and south. To the northeast, the Goshute Range hid in darkness.

The sun itself glowed fire-orange, a sunset palette that turned clouds into tangerine puffs with creamy underlayers and mountains into bruised purple silhouettes. When it dropped in the west behind North Schell, I remembered wandering those Schell Creek slopes in an unexpected summer snowstorm, recalled sitting atop the rocky north summit a year later. I thought about finding a lost cemetery at just this time of day, there in a canyon now shadowed across the valley. Looking at these ghosts, layered orange and mauve and gray, I pictured other blunt-shaped spirits hunkered in the distance.

I recalled the exotic names of places I've found on maps but haven't yet explored— Music Canyon and Horseshutem Springs and Billy Goat Peak and the Wassuk Range, for example—and I imagined their inhabitants—a solemn band of bighorn, a slow-moving desert tortoise, an elusive cougar sneaking through the aspen, a vulture soaring above the stillness. As the brief dusk quickly gave way to the dark, I considered what I like best. Above all, I relish the basin and range interplay of light and dark and space and distance, the corrugated textures, the geographic edges, the contours smooth and rough, the compass of silence. Since moving to Nevada I've adopted an aesthetic that embraces horizons unencumbered by the niceties most tourists enjoy, that unabashedly appreciates this special earthtone landscape. Accustomed now to remoteness and rattlers, I've taught myself to get over the color green. Along the way I've fallen in love, I confess, with Nevada's well-wrought terrain.

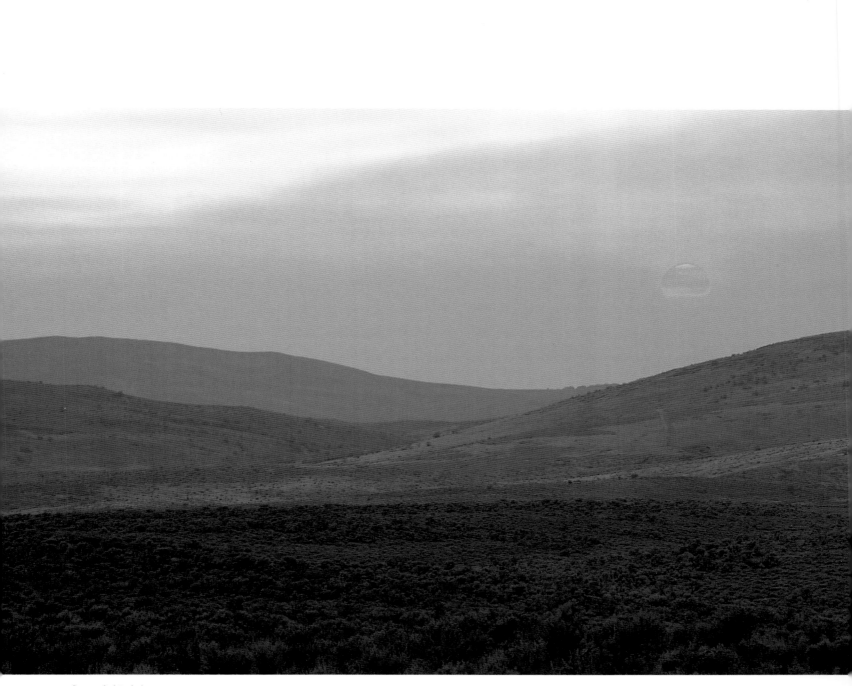

*Sunset behind the
Tuscarora Mountains
through a haze of smoke
from distant forest fires.*

Suggested Readings

John Muir's *Steep Trails* shows how an otherwise perceptive writer describes Nevada inappropriately; Mary Austin's *The Land of Little Rain* tempers his words. Starting with Muir and Austin, I then turned to more-recent portrayals of the complexities of Nevada and of perceptions of arid western terrain in general. I recommend John McPhee's *Basin and Range*, Robert Laxalt's *Nevada*, Wilbur Shepperson's *Mirage-Land*, and Wallace Stegner's *Where the Bluebird Sings to the Lemonade Springs*.

To understand the earth itself, I read William Fiero's *Geology of the Great Basin* several times. Fiero's Bureau of Land Management booklet, *Nevada's Valley of Fire*, and Cheri Cinkoske's *Red Rock Canyon* are helpful too. Samuel G. Houghton's *A Trace of Desert Waters* is a broad overview. I also enjoyed Sessions Wheeler's contributions, *Nevada's Black Rock Desert* and *The Desert Lake: The Story of Nevada's Pyramid Lake*. George Wuerthner's highly informative *Nevada Mountain Ranges* is essential for readers who want to learn more about the Great Basin's "army of caterpillars."

History buffs might combine Gloria Griffen Cline's *Exploring the Great Basin* with the nineteenth-century narratives of Clarence Dutton, John Frémont, and James Simpson. I used several documents quoted in Harold Curran's *Fearful Crossing* to project the full flavor of pioneer travel across the Nevada desert. More humorous is Mark Twain's *Roughing It*, more romantic, Idah Meacham Strobridge's *Sagebrush Trilogy*.

A useful, though dated, resource book about Nevada's oldest human residents is Robert Heizer and Martin Baumhof's *Prehistoric Rock Art of Nevada and Eastern California*. For my knowledge of ghost towns I relied on Shawn Hall's two books, *Romancing Nevada's Past* and *Guide to Ghost Towns and Mining Camps of Nye County, Nevada*, as well as Stanley Paher's *Nevada Ghost Towns and Mining Camps* and Firmin Bruner's *Some Remembered . . . Some Forgot: Life in Central Nevada Mining Camps*. Anecdotal tidbits can be gleaned from Helen S. Carlson's straightforward geographical dictionary, *Nevada Place Names*.

Those interested in ranching will learn historic information from James A. Young and B. Abbott Sparks's *Cattle in the Cold Desert*. Richard Symanski's *Wild Horses and Sacred Cows* posits a less sympathetic point of view. Darwin Lambert's *Great Basin Drama* spells out the conflicts among ranchers and conservationists and politicians over a Great Basin National Park. Almost every issue of *High Country News* helps clarify, in one way or another, the complexities of twentieth-century land-use disagreements.

To learn about the Nevada Test Site I read Dina Titus's *Bombs in the Backyard*. Richard Misrach's *Bravo 20: The Bombing of the American West* exposes the military's impact on the Silver State. The Spring 1994 *Citizen Alert* and the March 1994 *Popular Science* describe activities around Groom Lake. Although set in Utah, Terry Tempest Williams's *Refuge: An Unnatural History of Family and Place* best de-

picts the human costs of irresponsible nuclear testing.

I consulted all the available Nevada guidebooks, laughing at the *WPA Guide to 1930s Nevada*, enjoying the pavement tours of Al and Mary Ellen Glass's *Touring Nevada*, learning obscure facts from David W. Toll's *The Complete Nevada Traveler*, looking at Deke Castleman's *Nevada Handbook*, and occasionally reading Richard Moreno's *The Backyard Traveler* and *The Backyard Traveler Returns*. I paid special attention to the trips described by John Hart in his Sierra Club Totebook, *Hiking the Great Basin*, to the hikes outlined by Bruce Grubbs in *The Hiker's Guide to Nevada*, and to the suggestions made by Michael R. Kelsey in *Hiking and Climbing in the Great Basin National Park*.

I appreciated Jeanne L. Clark's *Nevada Wildlife Viewing Guide*, too. I could list dozens of standard reference books I used to check facts about western wildflowers and western wildlife. Most helpful were books in the University of Nevada Press's Great Basin Natural History Series—Ronald M. Lanner's *Trees of the Great Basin*, Hugh N. Mozingo's *Shrubs of the Great Basin*, Fred A. Ryser, Jr.'s *Birds of the Great Basin*, and William F. Sigler and John W. Sigler's *Fishes of the Great Basin*. Ronald J. Taylor's *Sagebrush Country: A Wildflower Sanctuary* and *Nevada Raptors*, published by the Nevada Department of Wildlife, were my two favorite regional guides. I also consulted brochures and handouts picked up in Bureau of Land Management offices, in U.S. Forest Service offices, in parks, and in countless communities throughout the state. Without the Nevada Department of Transportation's *Nevada Map Atlas*, I suppose I would have gotten lost more often than I did.

In an article I wrote five years ago, I fretted about the dearth of essays that relish the Nevada landscape. Now I can boast of writers who have been here all along—James Hulse, whose *Forty Years in the Wilderness* offers a historian's point of view; William Kittredge, whose *Owning It All* remembers a ranching boyhood. Diane Kappel-Smith, via *Desert-Time*, recently toured the Silver State like a dust devil. Ann Haymond Zwinger, with *The Mysterious Lands*, peruses the landscape more carefully and thus characterizes it more astutely, I think. For obvious reasons, however, my favorite Nevada book remains *The Sagebrush Ocean*, by Stephen Trimble, which I recommend because its pictures and prose savor the Nevada basin and range country in ways I appreciate most.